OXFORD

IN

50

BUILDINGS

ANDREW SARGENT

AMBERLEY

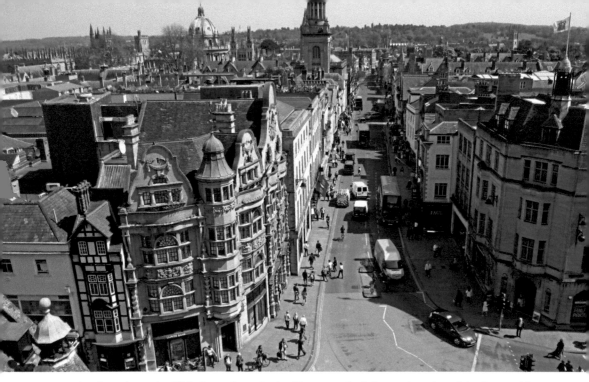

Looking down the High Street from Carfax Tower: to the left, are the spire of the former All Saints Church, the double towers of All Souls College North Quad, the dome of the Radcliffe Camera, and the entrance tower to Schools Quad cluster against the skyline.

First published 2016

Amberley Publishing, The Hill, Stroud
Gloucestershire GL5 4EP

www.amberley-books.com

British Library Cataloguing in Publication Data.
A catalogue record for this book is available from the British Library.

ISBN 978 1 4456 5987 9 (print)
ISBN 978 1 4456 5988 6 (ebook)

Typesetting and Origination by Amberley Publishing.
Printed in Great Britain.

Contents

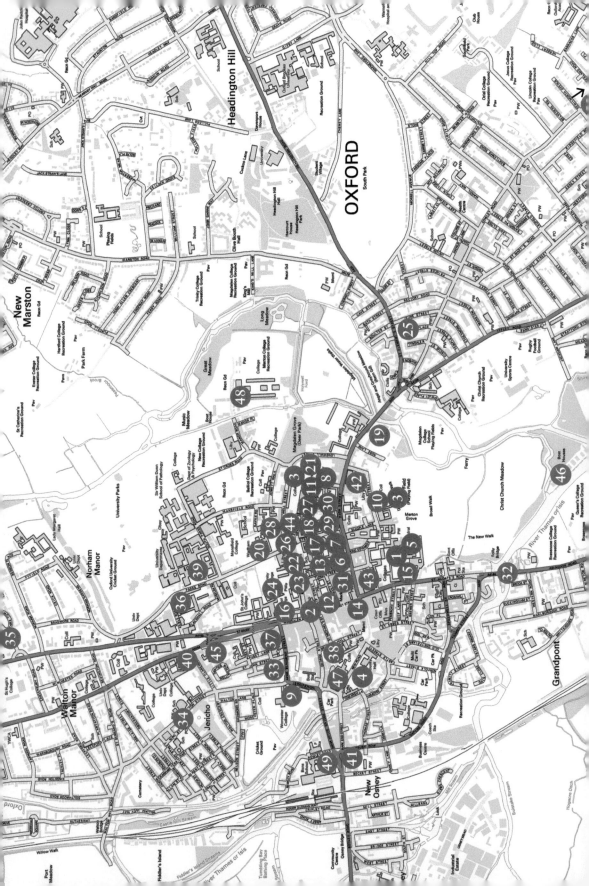

Key

1. Shrine of St Frideswide,
 Christ Church Cathedral
2. Tower of St Michael at the
 North Gate, Cornmarket
3. Town Wall
4. Oxford Castle
5. Christ Church Cathedral
6. St Mary the Virgin, High Street
7. Congregation House,
 St Mary the Virgin
8. St Edmund Hall
9. Worcester College
10. Merton College
11. New College
12. House on the corner of
 Cornmarket and Ship Street
13. Divinity School
14. Carfax Tower
15. Christ Church College
16. Martyrs' Memorial
17. Bodleian Library
18. Schools Quadrangle
19. Gateway, Botanic Gardens
20. Wadham College
21. Civil War Mound in
 New College Garden
22. Sheldonian Theatre,
 Broad Street
23. Old Ashmolean Museum,
 Broad Street
24. Chapel, Trinity College
25. Stone's Almshouses,
 St Clement's Street
26. Clarendon Building,
 Broad Street
27. North Quad, All Souls College
28. Holywell Music Room,
 Holywell Street
29. Radcliffe Camera
30. Nos 33–38 High Street
31. Covered Market
32. Folly Bridge
33. Beaumont Street
34. Jericho
35. Park Town
36. Keble College Chapel
37. Ashmolean Museum
38. Wesley Memorial Methodist
 Church, New Inn Hall Street
39. University Museum of Natural
 History, Parks Road
40. Somerville College,
 Woodstock Road
41. Jam Factory, Park End Street
42. Examination Schools,
 High Street
43. Town Hall, St Aldates
44. Bridge of Sighs
45. Eagle & Child, St Giles
46. College Boathouse
47. Nuffield College, New Road
48. St Catherine's College
49. Saïd Business School,
 Park End Street
50. Plant Oxford, Cowley

Introduction: Two Oxfords

An insignificant settlement stood at a crossing point on the River Thames before St Frideswide founded her abbey there in the late seventh century, and long before King Alfred the Great established a fortified burh around AD 900 as part of his system of frontier defences against the Vikings. Archaeologists have, remarkably, found traces of this Saxon ford at the bottom of St Aldates, complete with the hoof prints of cattle, while Alfred's street pattern still forms the framework of the modern town.

Oxford had been a thriving market town for several centuries before the first shoots of the future university gradually began to emerge. There is no foundation date for the university because its origin was not the result of an official decree but of dozens – hundreds – of individual decisions by 'masters'. These were essentially freelance teachers, wandering scholars looking for a suitable place in which to earn their livelihoods. The names of these pioneers are lost, but by the final decades of the twelfth century Oxford was beginning to establish a tentative reputation as a place of higher study. From that point, town and gown developed together like conjoined twins, though the university gained the upper hand.

At first, students lodged in the many academic halls, each presided over by a master who leased the building and was responsible for both discipline and delivering some teaching to his charges. However, in the thirteenth century, the now-famous college system began to develop; the first college was Merton, founded by Walter de Merton in 1264.

As partly religious institutions, the colleges only narrowly escaped being closed down when Henry VIII dissolved the monasteries and chantries. Even so, over the next few decades of Reformation and Counter-Reformation, Oxford saw martyrs on both sides of the Protestant/Catholic divide. Then, after an all too brief respite, the nation was torn by civil war. Charles I made Oxford his capital in 1642 as he retreated from defeat at Edghill, and the Parliamentary forces dug in for a siege. Charles surrendered in 1646, but it was not until Oliver Cromwell's death and the restoration of the monarchy under Charles II that the university became sufficiently confident to start building once more.

Town life also continued, though very much in the shade of the academic community. It was not until the mid-eighteenth century that the canal, and then the railway the following century, brought prosperity. However, perhaps the one person most responsible for the appearance of the modern town was William Morris, ennobled as Lord Nuffield. His decision to locate the Morris car factory at Cowley (just outside Oxford) in 1913 triggered huge economic growth. John Betjeman recalled that the Oxford of his childhood during the First World War was still a small market town surrounded by fields; between the wars, industrial production fuelled the spread of the suburbs, absorbing the nearby rural villages.

Change has characterised both town and university over their long life together, though, in the case of the university, this change is partly hidden behind tradition, ceremonial and venerable buildings. However, the story of both Oxfords can be traced in their architecture, as the particular attitudes and ambitions of each age were fossilised in bricks (or stone) and mortar.

The 50 Buildings

1. Shrine of St Frideswide, Christ Church Cathedral

A Site of Pilgrimage

Late seventh-century Oxford was just a small settlement beside a river crossing when a minor Saxon king, Didan, founded a convent for his devout daughter, Frideswide. As abbess, Frideswide attracted around herself a group of similarly minded noblewomen. Tradition tells of a certain King Algar of Leicester who decided to abduct and marry her. As he and his troops approached Oxford, they were miraculously struck blind and then, equally miraculously, received back their sight. Frideswide's reputation grew and, on her death in AD 727, a shrine to her was set up in the simple convent church.

Convent and church were sacked or destroyed on several occasions. The church was rebuilt once again in the twelfth century following the founding of an Augustinian priory. In 1289 the saint's mortal remains were translated to a more prominent location within the monastic church and a new shrine was erected over her. This became a popular place of pilgrimage – even Catherine of Aragon, first wife of Henry VIII, visited to ask for the miracle of a son. The wooden watching chamber was constructed by the canons in the late fifteenth century to keep guard over the richly decorated shrine.

St Frideswide was venerated from the earliest times. Her shrine became a place of pilgrimage. (By kind permission of the Dean & Canons of Christ Church Oxford)

The saint and her shrine attracted unwelcome attention during the Reformation. The shrine was broken up by militant Protestants but the saint's relics were hidden by faithful people. When Mary Tudor briefly restored the Catholic faith, Frideswide's remains were returned to the tomb, though no new shrine was erected. In the more mildly Protestant days of Elizabeth I that followed, the saint's bones were deliberately mixed with those of the wife of reformed theologian Peter Martyr in order to prevent veneration. They were then left in peace for three centuries. Not until 1889–91 were the surviving components gathered together and reconstructed on what is believed to be the site of the medieval shrine and of the saint's reinterred bones.

Though the present structure is a Victorian reconstruction of a thirteenth-century upgrade of the replacement Saxon shrine, it nonetheless provides a tangible link with the earliest history of the town – and with St Frideswide, who still rests beneath.

2. Tower of St Michael at the North Gate, Cornmarket

The Saxon Defences

King Alfred the Great (or his son Edward the Elder) created a series of fortified places or burhs to defend the frontiers of Wessex – Oxford was one of these. In the 880s or 890s, the old settlement was remodelled around a new centre at Carfax. The modern street plan

The Saxon tower of St Michael's church on Cornmarket.

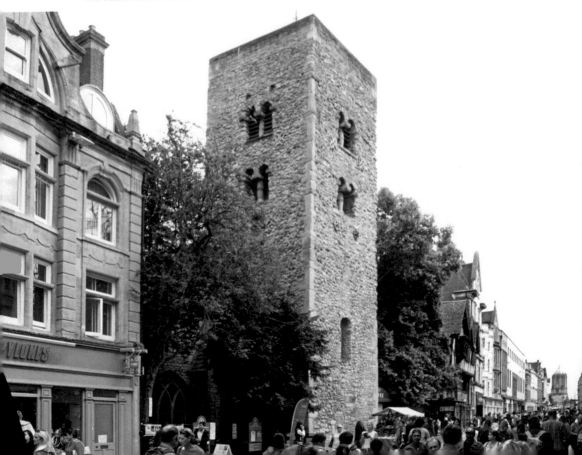

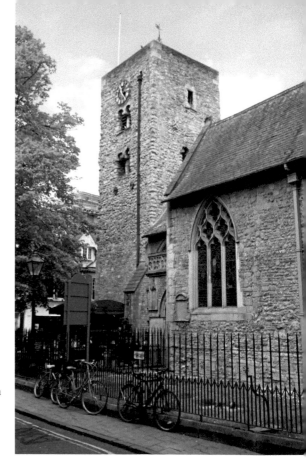

Right: The church of St Michael with its Saxon tower from Ship Street.

Below: Typical Saxon bell openings in the south and west faces of the tower.

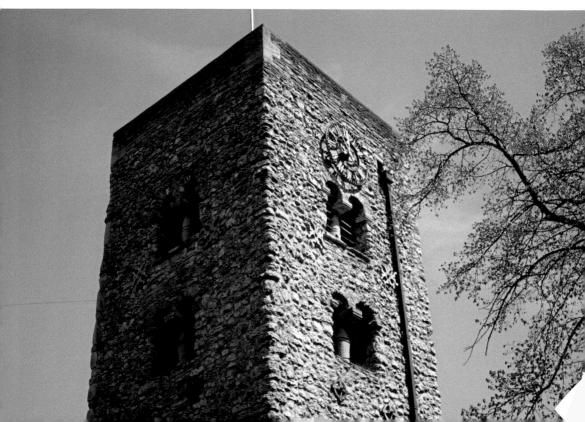

still preserves the bones of the Saxon layout: the High Street, St Aldates, Queen Street and Cornmarket follow the lines of the main Saxon roads, while lanes such as Catte Street and Magpie Lane trace the earliest town ramparts. Oxford was now important both strategically and commercially, and within just a few years the thriving burh was extended eastwards almost to Longwall Street, perhaps to control the crossing of the River Cherwell.

The oldest building in Oxford is the tower of St Michael at the North Gate. This church, at the junction of Cornmarket and Ship Street, dates from the early eleventh century. Classic Saxon 'long-and-short' masonry can be seen at the corners, while the round-topped windows are divided by heavy, shaped balusters. However, its story is not straightforward. This strong tower once served a vital military role. Initially, it was not attached to the church, but was built into the town wall to form part of the north gate. The outline of a blocked doorway is visible, which gave access onto Cornmarket and may have provided pedestrian access through the base of the tower when the main town gates were closed. Another doorway, at second-floor level on the north side, probably opened onto the wall walk. It was not long before the rampart and ditch were diverted northwards a few meters to allow space for a church and graveyard, though the tower remained an integral part of the north gate throughout the Middle Ages. Apart from its ancient tower, no trace of the Saxon church of St Michael remains; much of the present church dates from the thirteenth and fourteenth centuries.

3. Town Wall

Security Cordon

The burh, founded by Alfred the Great (or his son) in the late ninth century, was intended as a defensive strongpoint. It was encircled by an earthen rampart with an external ditch; an intramural road ran inside the circuit to facilitate troop movement. Within just a few years, the prosperous burh was extended towards the crossing point of the River Cherwell, and its rampart appears to have been faced in stone at the same time. This did not prevent the town being sacked by the Danes in 1009, 1010 and 1013, as recorded in the Anglo-Saxon Chronicle. On the final occasion, the citizens surrendered hostages as a guarantee of obedience and tribute.

The next rulers, the Normans, were content to retain the Saxon defences, adding a castle of their own beside the west gate – their concern being to protect themselves from the townsfolk, rather than the town from marauders. The old walls had to withstand one further siege. The civil war known as The Anarchy (1135–54) was near stalemate when, in 1142, King Stephen trapped his cousin and rival for the crown, the Empress Matilda, in Oxford. Then, one snowy night, just when it appeared the war was nearing a conclusion, Matilda slipped quietly away across the frozen Thames. Stephen's frustrated forces ravaged and burned Oxford – the rampart had not saved them.

It was not until the thirteenth century that the old Saxon town rampart was rebuilt in masonry, almost precisely following the line of the earlier defences. It was pierced by four gates on the four main streets, while the ditch outside the walls formed a dry moat. However, by this period England enjoyed security and prosperity, and the authorities saw the wall more as a statement of civic pride than a serious military requirement.

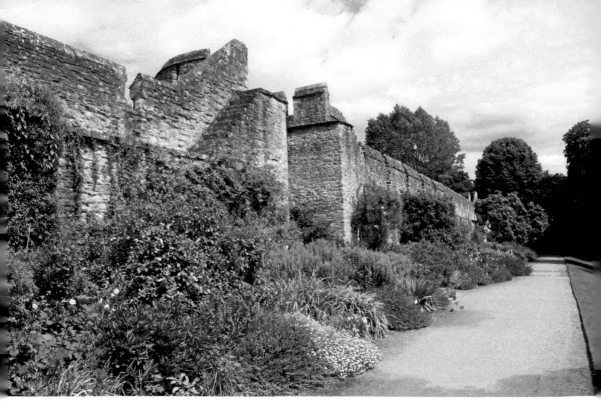

Above: The best-preserved section of the thirteenth-century town wall can be seen in New College gardens. (By permission of the Warden and Scholars of New College Oxford)

Below: A bastion on the town wall provides a quiet corner for reflection in New College gardens. (By permission of the Warden and Scholars of New College Oxford)

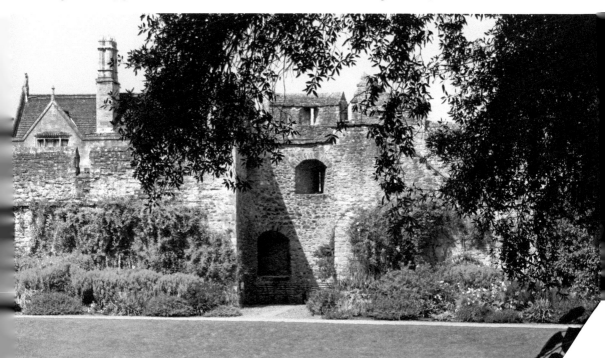

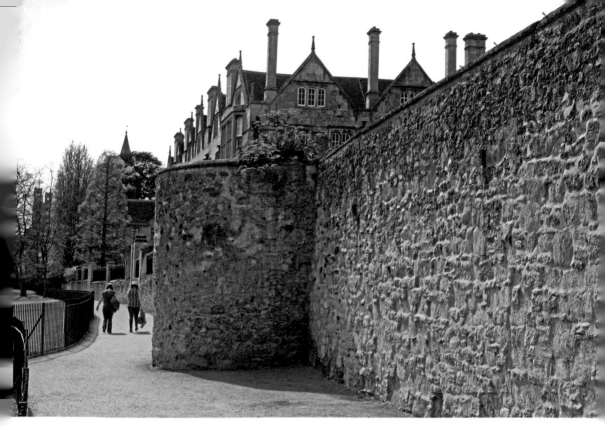

This bastion, bordering Deadmans Walk, is fossilised in the boundary wall of Merton College.

The lines of the wall and ditch are preserved in the modern street plan, but little is visible above ground. The best surviving portion of the thirteenth-century wall may be seen in the gardens of New College, while another length including a bastion forms the perimeter wall of Merton College, alongside Deadmans Walk.

4. Oxford Castle

A Mailed Fist

When William the Conqueror seized England in 1066, one of William's Norman knights, Robert d'Oilly, was given responsibility for Oxford. To secure his new position, in 1071 d'Oilly built a simple motte-and-bailey castle inside the west gate, in the process sweeping away a section of the Saxon town and diverting Queen Street northwards to a new west gate. Over the centuries, as its lords gained in confidence and wealth, the castle was enlarged and upgraded. At one point, the earthen motte (or mound) was crowned with a ten-sided masonry keep of which no trace now remains. A thirteenth-century well chamber, sunk deep into the mound and accessed via a flight of steps, provided insurance against a long siege. The prominent St George's tower may date from the late eleventh century. Built defensively into the castle wall, it perhaps doubled as the bell tower for the chapel of St George, which was also founded by Robert d'Oilly.

When its military function began to decline, the castle continued as an administrative centre. In the seventeenth century it was converted into a gaol. It also housed the county court.

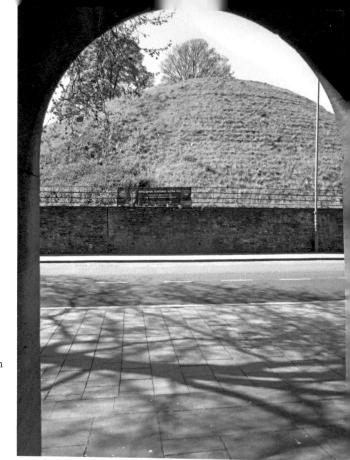

Right: The 64-foot-high earthen motte (or mound) of Oxford Castle, thrown up in 1071, was originally topped with a wooden defensive tower.

Below: St George's Tower is built into the curtain wall of the castle, but may have doubled as the bell tower for the castle chapel.

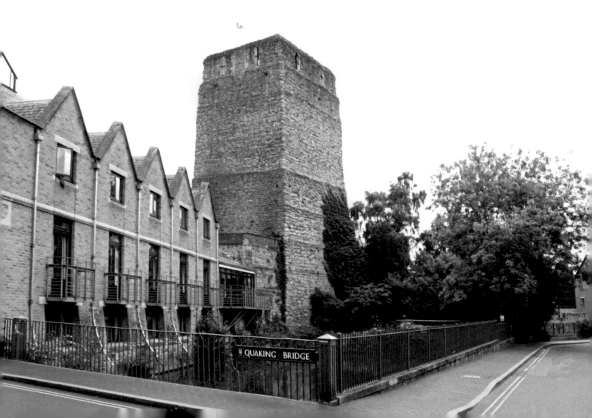

QUAKING BRIDGE

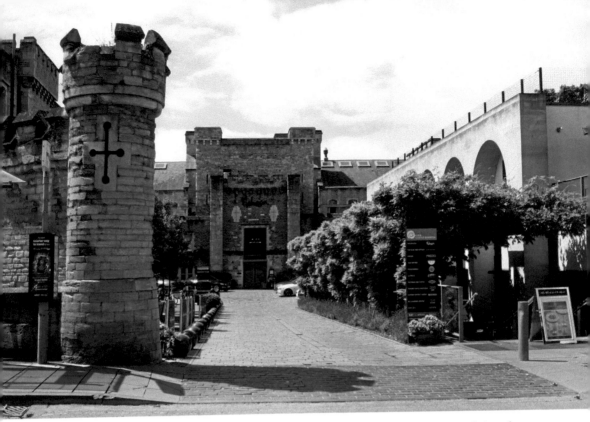

The castle became a prison. The prison entrance wing at the end of its approach is today a luxury hotel.

Following a critical report into conditions in the 1770s by the prison reformer John Howard, much of the prison was rebuilt – note the ranks of small, barred windows. It finally closed in 1996. The castellated County Hall was designed by the architect John Plowman in 1840–41 to echo the military style of its neighbour.

D'Oilly's 65-foot-high earth motte still dominates the western approach to the old town along New Road and Queen Street. The site is now open to the public for the first time in its long history, offering a series of recreational activities. Both motte and well chamber may be visited, tours of the castle are available, and it is even possible to spend the night in a cell (a privilege that townsmen were once keen to avoid).

5. Christ Church Cathedral

From Nunnery to Cathedral

Oxford is a cathedral city, though this is not immediately obvious since Christ Church is well hidden, buried within the college of the same name and which it serves as a chapel. The best exterior view is from the former monastic cloister on the south side. It is also the smallest cathedral in England, at only 175 feet in length (Winchester is almost 400 feet longer) and barely 100 feet at its widest. Its story, however, is much older than the college or university, as it stands in direct continuity with St Frideswide's seventh-century nunnery and church and contains her shrine.

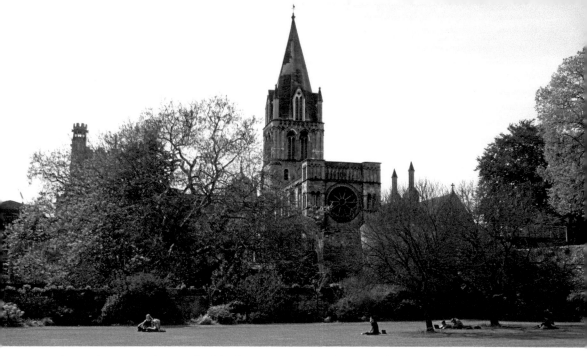

Above: The spire and east end of the former priory church, now Oxford Cathedral, rise from the surrounding huddle of Christ Church College.

Below left: Looking east along the twelfth-century nave and choir of the former priory church, now the cathedral. (By kind permission of the Dean and Canons of Christ Church Oxford)

Below right: The cathedral spire from the cloister of the former Augustinian priory.

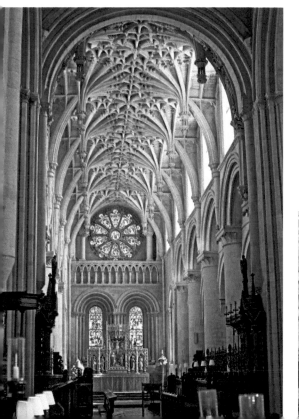

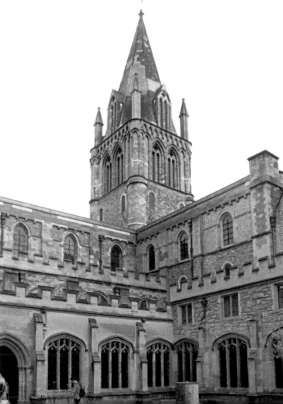

The first nunnery church was probably wooden, and was destroyed and rebuilt many times. In 1002, it was the scene of an atrocity when King Æthelred II gave orders for all the Danes in his kingdom to be surprised and slaughtered on St Brice's Day. In Oxford, the Danish community sought sanctuary in the church, which the mob burned down around them. The town was subsequently sacked by the Danes in 1009, 1010 and 1013; it is unlikely that the priory escaped. In around 1120, Henry I refounded the nunnery as a priory of regular Augustinian canons who rebuilt it yet again, this time in stone. The earliest surviving parts of the cathedral date from this period. In common with most large churches, its history is one of constant addition and alteration; for example the massive piers of the nave and choir are twelfth-century survivors, while the vaulted ceiling of the choir dates from around 1500.

Cardinal Wolsey acquired the site in order to clear it for his great college, which was to include a new college chapel. The west end of the priors' church was demolished to lay out Tom Quad, but most was still standing when Wolsey fell from power in 1529. Henry VIII elevated this church to the rank of cathedral for his new diocese of Oxford, at the same time linking the institutions of cathedral and college: the dean of the cathedral is also the head of Christ Church College.

6. St Mary the Virgin, High Street

University Church

St Mary was the dominant church of Oxford long before the university was dreamed of. Its Saxon predecessor stood beside Alfred the Great's original east gate, and was left to preside over the High Street when the burh was extended eastwards and a new east gate and chapel (of Holy Trinity, long-since demolished) were built.

St Mary is a substantial church, dominated by its spire; the view from the tower over the town and colleges is a popular attraction. The visitor will usually enter by the south porch with its barley-twist columns – a startling example of baroque in an otherwise medieval and classical town. This porch was designed by Nicholas Stone in 1637 at the expense of Dr Morgan Owen, chaplain to Archbishop Laud. The statue of the Virgin and Child over the door was targeted (quite literally) during the Civil War and has since been restored. The tower is late thirteenth century, with the spire added around 1320. Otherwise, most of what can be seen is Perpendicular in style, dating from the fourteenth and fifteenth centuries, with its large windows making the interior light and spacious.

When the first independent teachers or 'masters' (so termed because they had an MA, the teaching qualification for higher education) banded together to form the guild that developed into the university, St Mary was naturally chosen for their formal assemblies. Students took their oral exams in the church. On a more sombre note, bishops Ridley and Latimer and Archbishop Cranmer, the Oxford martyrs, had show trials here before being burned at the stake in 1554 and 1555. University funds and important documents were kept in St Mary's, securely locked in the university chest. Even when the university began to own property, St Mary remained – and still remains – the official university church.

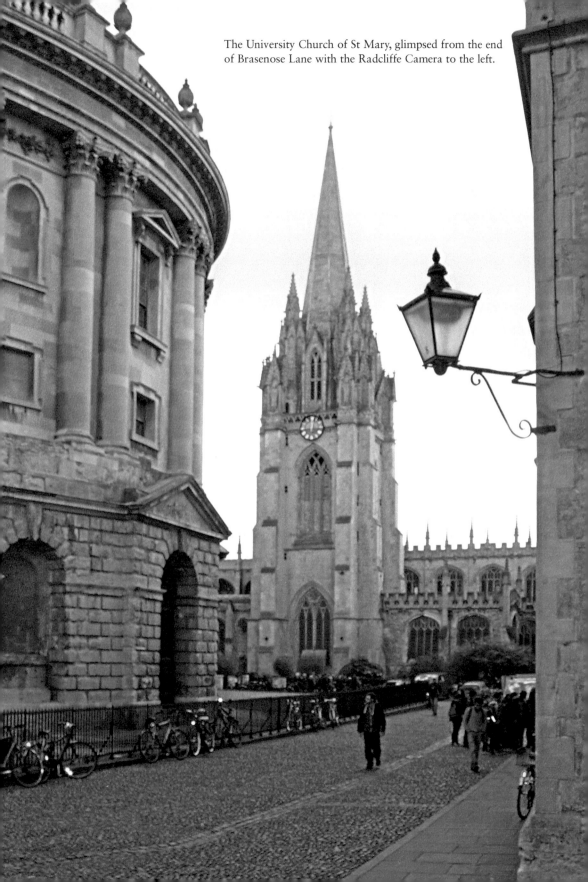
The University Church of St Mary, glimpsed from the end of Brasenose Lane with the Radcliffe Camera to the left.

Left: The spire of 1315–25 dominates the town centre and offers breathtaking rooftop views.

Below: St Mary's faces the High Street. The striking baroque south porch was designed by Nicholas Stone in 1637.

7. Congregation House, St Mary the Virgin

Growing University Identity

The Congregation House was the first property owned by the maturing university as it began to consolidate its position. Prior to this, all large university meetings and activities shared public space in St Mary the Virgin. Inevitably, this lack of dedicated private space became an issue.

In the 1320s, a purpose-built two-storey building was grafted onto the north side of the Church of St Mary, and university administrative meetings were transferred there from the adjoining church. The 'regent masters' (MAs who held university or, later, college posts) gathered in the lower chamber or undercroft to transact official business. The upper chamber, with larger windows and altogether more airy, became the university library. Here, the small but precious collection of manuscripts bequeathed by Bishop Cobham could be consulted by regent masters: at this time undergraduate teaching did not require access to expensive books. When the university library was moved to Duke Humfrey's Library in around 1490, the Congregation relocated to the better-lit room upstairs.

Today, the lower chamber, with its vaulted ceiling and small window openings, serves as the café for visitors to the Church of St Mary the Virgin.

The Congregation House of the 1320s was built against the north side of the chancel of St Mary's as a venue for conducting university business.

8. St Edmund Hall

Controlling Discipline and Teaching

The colleges for which Oxford is famous were relative latecomers to the university. Before the college system evolved, students either rented a room in the town or lived in one of the numerous academic halls. Each hall was privately owned, under the control of a master on whom it depended for its quality and tone. He leased the building and usually provided students with lodging, meals and much of their teaching. Many closed as others opened, while some amalgamated to make economies of scale. As the university gained in authority, the halls and their masters were registered annually by the chancellor in an attempt to maintain academic standards and discipline.

From the street, most halls would have been indistinguishable from their non-academic neighbours. Many were simply converted houses, though others were purpose-built. For example, Tackley's Inn in the High Street was built around 1300 by Roger le Mareschal to be let out as an academic hall, combining a row of single-storey shops on the street frontage with a hall and chambers behind. Parts of Roger's hall survive within a later building. As ideas developed, the better appointed halls increasingly came to look like the new college quadrangles. At the start of the fourteenth century, there were over 100 halls at any one time. There were still around seventy in the mid-fifteenth century, but only eight a century later as the better organised colleges increased in number and popularity.

The modest entrance to St Edmund Hall.

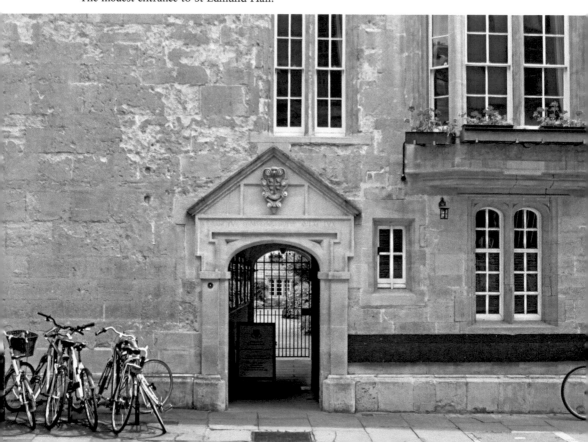

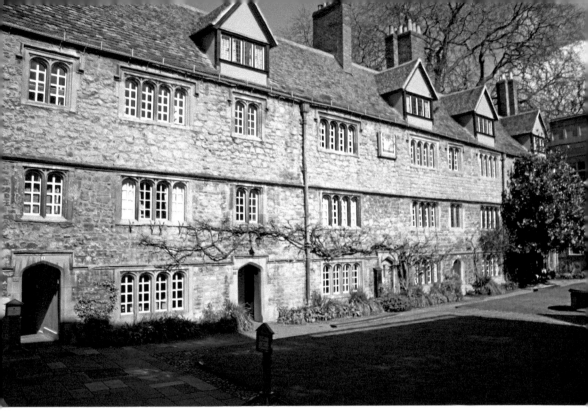

Above: This range of buildings in Front Quad dates from the sixteenth and eighteenth centuries.

Right: The redundant church of St Peter-in-the-East is now the college library. The statue represents St Edmund of Abingdon (d.1240), a university teacher who later became Archbishop of Canterbury.

Only three halls continued into the modern era. In 1881, St Alban Hall was absorbed into neighbouring Merton College, while in 1902 St Mary Hall was united with Oriel College. The only true survivor is St Edmund Hall. The name first appears in a rental document in 1317 when its landlord was Osney Abbey, though due to constant renovation its earliest buildings date only from the sixteenth and seventeenth centuries: for example, the dilapidated fifteenth-century refectory was replaced in 1659. Remarkably, St Edmund Hall (known affectionately as Teddy Hall) endured and, in 1957, was belatedly accorded college status.

9. Worcester College

A Centre for Monastic Study

As the university's reputation grew, unsurprisingly the religious orders wished to share in its benefits. However, the chaotic nature of student life was unsuitable for a novice. The solution was for each order to manage its own centre of academic study (or studium).

Below left: This range of cottages in Worcester College was the original accommodation for the student monks of Gloucester College. (By permission of the Provost and Fellows of Worcester College, Oxford)

Below Right: The substantial chimney of the monastic kitchen hints at the corporate life of the college. (By permission of the Provost and Fellows of Worcester College, Oxford)

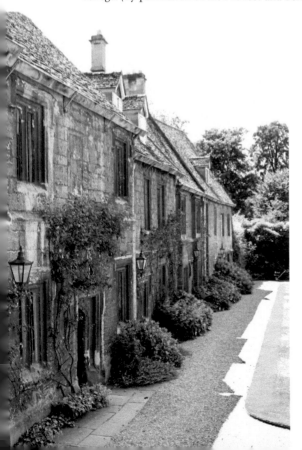

For the friars, learning had an urgent purpose – to equip more effective preachers and to combat heresy. The Dominicans and the Franciscans established houses in Oxford in 1221 and 1224 respectively. These were followed by the lesser orders: the Carmelites (1256), Friars of the Sack (1261–62) and the Austin Friars (1266–67).

The monastic orders were slower to recognise the advantages of a university education. The Cistercian studium, Rewley Abbey, was only established in 1281. The Benedictine Order quickly followed with Gloucester College in 1283, while the wealthy houses of Durham (in 1286) and Christ Church Canterbury (in 1361) each founded their own studia; the Cistercian St Bernard College arrived in 1437. The powerful Augustinian Osney Abbey, to the west of the town, was apparently never interested in academic study.

When the monasteries were dissolved by Henry VIII, the studia followed their mother houses into oblivion. In some cases, fragments survive: for example, a few yards of the precinct wall of Rewley Abbey pierced by a pedestrian gateway near the Oxford Canal, or a reused gateway from the Augustinian canons' studium in New Inn Hall Street. Others were bought up wholesale by secular founders to be recycled as ready-made colleges. Among this group the best-preserved example is St Bernard College, which forms the Front Quad of St John's.

This blocked gateway in Walton Street was an entrance to Gloucester College. Above it are the arms (left to right) of Ramsey Abbey, St Albans Abbey and Winchcombe Abbey.

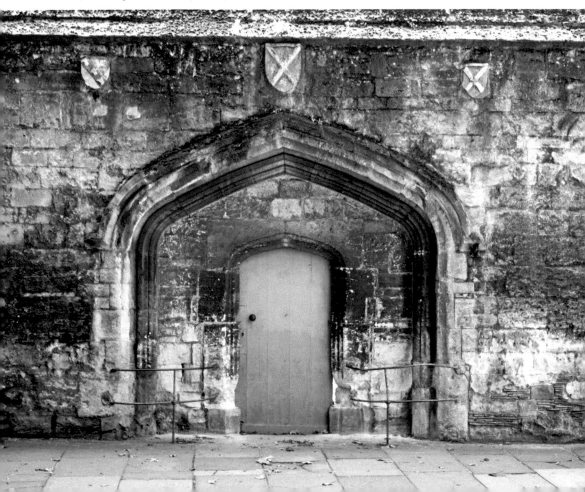

The most picturesque survival is to be found in Worcester College, the former Gloucester College. After its dissolution, various institutions existed precariously on the site until it was refounded in 1714 as Worcester. A row of cottages on the south side of the main quad gives a clear impression of how the monastic college was ordered. Each was the hostel for a different Benedictine house; coats of arms over the doors indicate the parent houses. Despite this, college life was corporate, as testified by the substantial kitchen chimney breast.

10. Merton College

A Collegiate University Emerges

The institution with the best claim to the title of Oxford's first college is Merton College, founded in 1264 by Walter de Merton. Wealthy and influential, he served as chancellor to Henry III and Edward I and subsequently as bishop of Rochester (d. 1277). His foundation was designed to support twenty scholars from the profits of an estate at Malden, Surrey. Walter de Merton patiently assembled a 1-acre plot in St John's Lane from a patchwork of small tenements, including the neighbouring St John's church which initially served the scholars as a chapel. One tenement was bought from Jacob, son of Moses, a member of Oxford's Jewish community; others from powerful landowners such as St Frideswide's Priory and Reading Abbey.

Detail of the main gateway of Merton College, with the sculpted panel by Robert Janyns (1464–65).

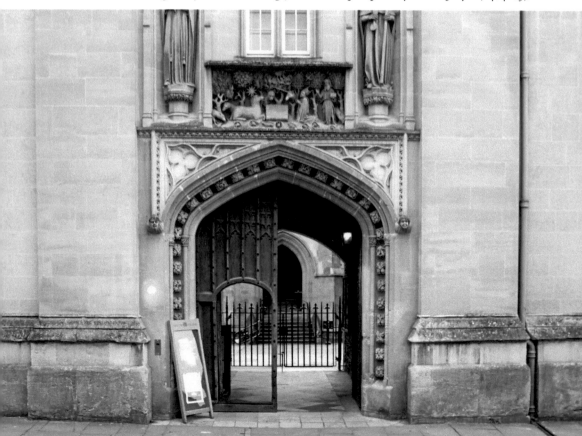

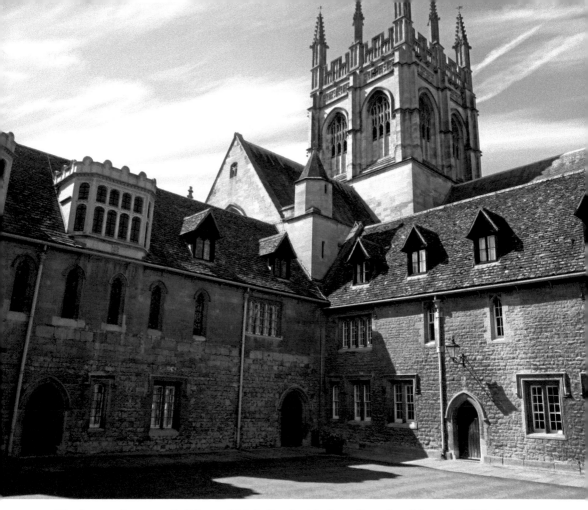

The fourteenth-century buildings of Mob Quad with the college chapel beyond. (With the permission of The Warden and Fellows of Merton College Oxford)

Merton's innovation was to conceive of a self-governing academic community, supported by endowments vested in the members corporately and regulated by statute in order to achieve the founder's purposes. This legal foundation gave the stability and security that the informal academic halls lacked.

Equally influential was the architectural form chosen to express this community – the quadrangle. The Front Quadrangle contains the elements of hall, chapel and gatehouse, though it is irregular in shape. The thirteenth-century hall, which, unusually, is on the first floor, served for both communal meals and academic exercises. The ironwork of its main door dates from around 1275. A college chapel had been built by 1291 and the former St John's Church was demolished. Mob Quad, with construction beginning in 1304, is claimed as the first complete quadrangle in the university. Accessed via a vaulted passage beneath the fireproofed treasury tower, it provided accommodation, though a library was soon located on the first floor. However, unlike its monastic cousins, it has no cloister.

When further colleges were founded – University College (1280), Balliol (1282), Exeter (1314), Oriel (1326), The Queen's (1340) and New College (1379) – they either copied or adapted the legal and architectural model set by Merton and Mob Quad.

Looking through from Patey's Quad to Mob Quad. (With the permission of The Warden and Fellows of Merton College Oxford)

11. New College

An Experiment in Undergraduate Teaching

New College was founded in 1379 by William of Wykeham, bishop of Winchester, whose driving purpose was to produce educated priests to fill church and government posts. It was conceived as part of an integrated education system in which the ablest scholars would progress from Wykeham's other foundation, Winchester College (a grammar school).

Prior to this, Oxford's colleges were only open to graduates studying for higher degrees – undergraduates lodged in academic halls or in rented rooms. Wykeham's innovation was for a college to admit undergraduates, providing both educational and pastoral oversight. Although this idea was only slowly adopted, a university statute from around 1410 requiring students to live either in halls or in colleges in order to combat perennial issues of discipline demonstrates that the option was recognised. Today, of the traditional colleges only All Souls has resisted the pressure to admit undergraduates.

New College's Great Quad was built in one campaign, and included all the necessary elements of a college: gate tower, chapel, hall, library and accommodation. The chapel followed Merton's example in having no nave: as all the scholars and fellows were in holy orders, no lay congregation would be present. Unusually, a cloister provided space for contemplation.

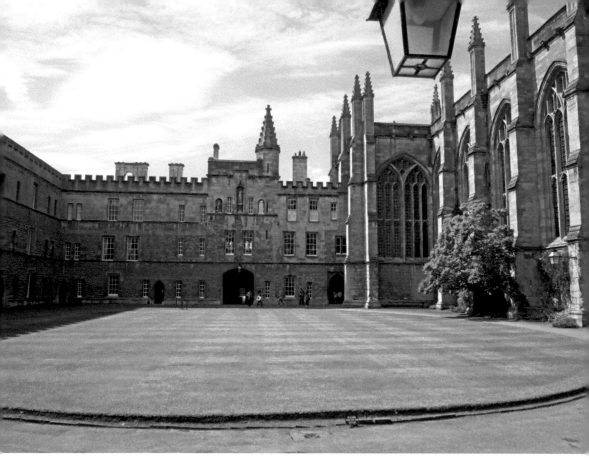

The Great Quad of New College, founded in 1379 to provide undergraduate teaching for scholars from Winchester College. (By permission of the Warden and Scholars of New College Oxford)

12. House on the Corner of Cornmarket and Ship Street

A Surviving Medieval Town House

Late medieval Oxford was a prosperous town of merchants and shops, an important regional market centre as well as a university town. A surprising number of buildings from this time remain hidden beneath later façades and accretions. A well-preserved example stands prominently on the corner of Ship Street and Cornmarket, opposite the south door of St Michael at the North Gate.

In the final decade of the fourteenth century, John Gibbes, sometime mayor and MP for Oxford, leased the plot from St Michael's Church to build houses. Despite the constricted site, this was a prime location on a main commercial thoroughfare. The building is half-timbered and three storeys high. Its upper floors project over the roadway in order to steal extra space, while a bay window on each floor was a sign of wealth. It was probably built as a merchant's house, perhaps over his business, though its use and status must have changed many times in the intervening centuries – it may, at one stage, have been incorporated into the adjoining New Inn. The whole structure seems to twist on its original corner post, conveying a sense of enormous weight.

A fine example of a late medieval merchant's house.

13. Divinity School

An Ambitious Building Project

At the start of the fifteenth century, the Congregation House attached to St Mary's Church was still the university's sole property, while lecture rooms or 'schools' were rented. However, the university's income, mostly from fees and fines, was now sufficient to allow an ambitious new building to be planned. It was decided to build a new Divinity School that was worthy of this, the highest of the faculties. This was to be free-standing, a large and imposing single-storey room measuring 87 feet by 31 feet with a splendid vaulted ceiling, which could also host corporate ceremonies. Work began in the 1420s, alongside a fundraising campaign. Letters were sent to prominent clerics, monastic houses and other likely benefactors. In the event, dogged by financial problems, with three different architects, complicated by changes in design and despite various economies, work progressed slowly and was not finally completed until 1490.

The project was redefined when, in 1444, Duke Humfrey of Gloucester, youngest son of Henry IV, made the university a gift of 281 volumes. This was so generous that the university undertook to build a second storey over the as yet incomplete Divinity School to

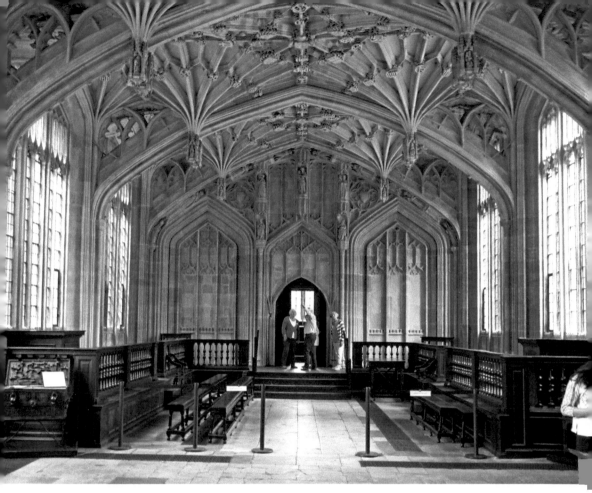

It took seventy years to complete this grand space for the teaching of theology, the most prestigious of academic subjects.

house the collection. This new room was to be known as Duke Humfrey's Library. Once it was ready, the old university library was transferred there from the Congregation House, though access to this valuable resource was still restricted to senior members.

The successive theological purges of the Reformation years devastated the library. Following its restoration by Sir Thomas Bodley, a vestibule with a library room (called the Arts End) above was added at the eastern end. This vestibule, known as the Proscholium, now forms the entrance to both the Bodleian Library and the Divinity School. The Convocation House was added to the western end of the Divinity School in 1634, with a further library extension known as the Seldon End above it on the first floor.

14. Carfax Tower

The Medieval Civic Church

Carfax Tower is one of the landmarks of Oxford. The tower stands 74 feet tall, and no taller building is permitted in the town centre. Its roof platform, up a spiral staircase of ninety-nine steps, is an excellent viewpoint from which to survey the Oxford skyline.

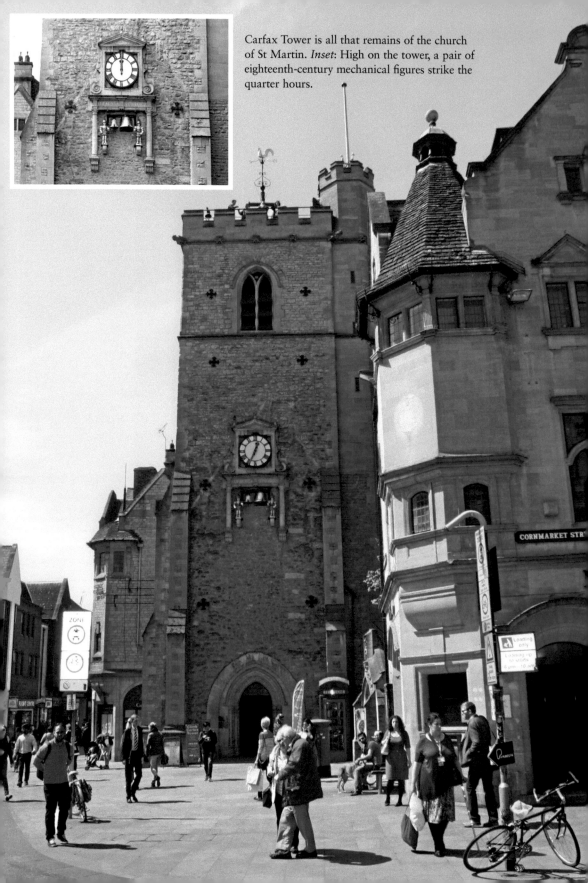

Carfax Tower is all that remains of the church of St Martin. *Inset*: High on the tower, a pair of eighteenth-century mechanical figures strike the quarter hours.

The new burh, laid out in the ninth century, was planned on a regular grid pattern. The crossroads at its heart became known as Carfax, said to be derived from the French *quatre voies* meaning 'four ways' or *carrefour* meaning 'crossroads', from which the four main streets radiate towards the cardinal points. A Saxon church of St Martin already commanded this important junction when, in 1032, King Cnut granted it to Abingdon Abbey. It was rebuilt in the medieval period, becoming the official church of the town's governing corporation and rival to the University Church of St Mary the Virgin. In 1820, it was found to be structurally unstable and was rebuilt, before finally being pulled down in 1896 to make way for road widening – the public conduit (fountain) in Carfax which brought clean water from Hinksey Hill had already made way for street improvements in 1787.

The thirteenth-century west tower of St Martin's was saved from demolition and restored by T. G. Jackson as a freestanding structure. Since 1554 the church had displayed a clock at its east end, to which a pair of mechanical figures to strike the quarter hours had been added by the eighteenth century. The clock and figures were mounted on the tower in 1896 as part of Jackson's restoration.

15. Christ Church College

Cardinal Wolsey's Pride

Cardinal College was the dream of Cardinal Thomas Wolsey. It was to be a statement, the largest and grandest college in either university; Tom Quad remains Oxford's largest quad. Its construction was funded from his enormous wealth, though even he had to suppress several monastic houses to provide a suitable endowment. The Augustinian priory of St Frideswide, successor to the saint's own abbey, was acquired to provide a site within the crowded town.

Work began in January 1525, but came to a halt with Wolsey's unexpected fall from power late in 1529. By this date the hall and kitchen were complete, two ranges of accommodation and the south-west tower were inhabitable, the gate tower was partially erected and the walls of the new chapel had reached head height – they remained until the 1660s. His plans included the demolition of the priory church – but it survived. A cardinal's cap motif forlornly decorates the corner towers of Tom Quad as a reminder of Wolsey's overweening ambition.

Henry VIII took over the partly built college, along with much else that had been Wolsey's, and the renamed King Henry VIII College camped in the building site. Then, in 1546, Henry elevated the former priory church to the rank of cathedral. With a new purpose, the college was refounded as Christ Church College, and the two institutions were linked. The cathedral still serves as the college chapel. The buildings of the neighbouring Canterbury College, the former Benedictine studium, were also granted to the college; its name is commemorated in Canterbury Quad.

Samuel Fell, Dean of Christ Church, completed the great quadrangle that had lain half built since Wolsey's downfall over a century earlier, very deliberately continuing the Tudor style of the original to create an architectural unity. Architect Sir Christopher Wren was engaged to complete the great gateway leading into Tom Quad from St Aldates. He adapted

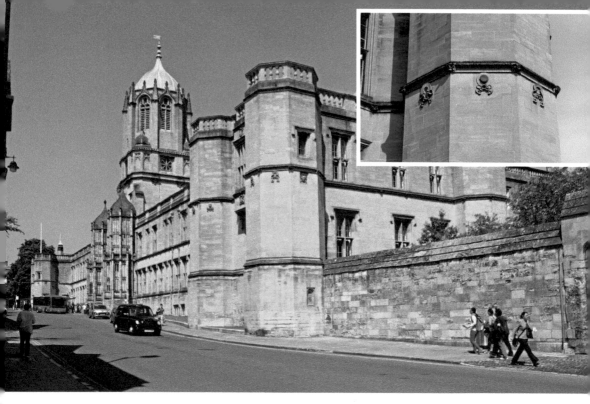

Above: Christ Church College from
St Aldates. *Inset*: A decorative motif of
cardinal's caps is a reminder of Wolsey's
over-ambition.

Left: Tom Quad, laid out by Cardinal
Wolsey, is the largest quadrangle in Oxford.

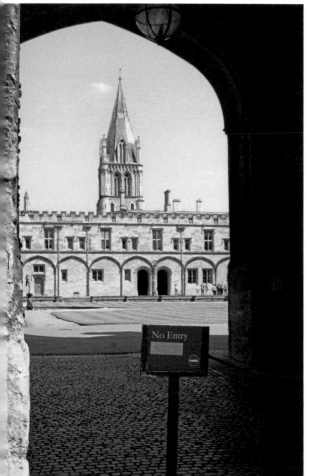

Wolsey's original plan to take a bell, and the 7-ton Great Tom, which 150 years before had hung in the abbey church at Osney, was recast and relocated. It first tolled the curfew on 29 May 1684.

16. Martyrs' Memorial

Oxford's Protestant Heritage

The sixteenth century was an unstable time for the nation. The fuse primed by Henry VIII's need for a male heir was lit by his decision to divorce his queen, Catherine of Aragon, and marry the young, and hopefully fecund, Anne Boleyn. The cost of this dynastic imperative was to prove considerable.

As conflict with the papacy became inevitable, Henry began to flex his muscles. Following his excommunication in 1533, Henry audaciously proclaimed himself Supreme Head of the Church of England. Then, in 1536–41, he dissolved the increasingly irrelevant monasteries, and with them the monastic studia of Oxford. It was left to Henry's only son and heir, Edward VI, to carry this policy forward as the English Church became increasingly Protestant.

When Edward died in 1553, aged only fifteen, his elder sister Mary succeeded to the throne. As daughter of Catherine of Aragon, she remained stoutly Catholic and it was the turn of the Protestants to suffer. Although many went to the stake, Oxford witnessed

Martyrs' Memorial commemorates Cranmer, Latimer and Ridley who died for their faith in Oxford in 1555–56.

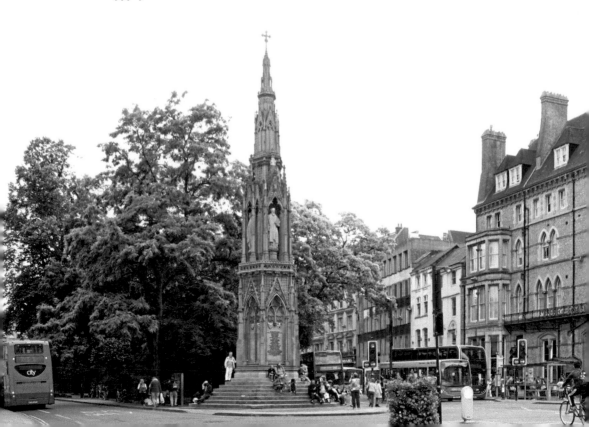

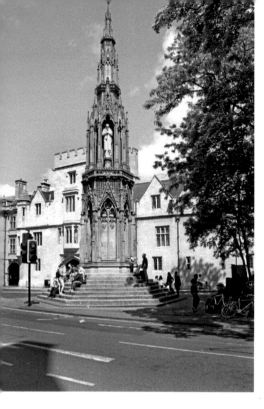

Martyrs' Memorial was erected in the 1840s.

the trial and execution of three influential men: bishop Hugh Latimer of Worcester, bishop Nicholas Ridley of London and, most shocking of all, the sixty-six-year-old Thomas Cranmer, Archbishop of Canterbury. Latimer and Ridley were publicly burned on 16 October 1555 in the Broad; Cranmer was burned separately the following year. It should be noted that, with the accession of Elizabeth I, the religious seesaw tipped again. Some thirty Oxford priests, fellows of colleges, were executed as Catholics; a plaque near the corner of Holywell Street and Longwall Street records the execution of four Catholic priests.

The famous Martyrs' Memorial at the head of St Giles' commemorates Cranmer, Latimer and Ridley. It was designed in Gothic style by George Gilbert Scott and set up almost three centuries after the event, in 1841–43, as a sobering reminder of the cost and values of the Protestant Reformation. However, it does not mark the actual place of execution, which is indicated by a simple cross in the cobbles at the west end of Broad Street.

17. Bodleian Library

A New Approach to Learning

Before the invention of printing, university study was based on oral exercises rather than book learning. A small room over the Congregation House sufficed to hold the university's library until a new room was added to the Divinity School to house Duke Humfrey's lavish bequest of manuscripts. Two decades of heresy hunting during the reigns of Edward VI and Mary left this library virtually stripped of both books and fittings; the room itself was taken over by the Faculty of Medicine. At the same time, the development of printing was beginning to change academic culture as books became more accessible.

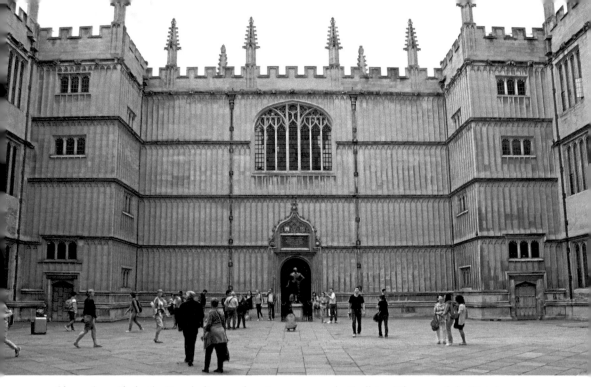

Above: A vestibule, the Proscholium, today gives access to the Bodleian Library and the Divinity School. A library room known as the Arts End occupies the first floor.

Below: Duke Humfrey's Library (first-floor windows) was built over the new Divinity Schools to house his valuable bequest.

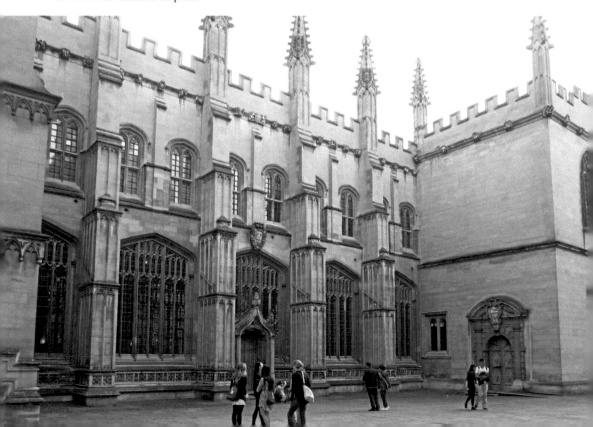

In the stable political climate of Elizabeth's reign, a fresh start was made. In 1598, Sir Thomas Bodley, a fellow of Merton College who served for many years as a diplomat and ambassador to Elizabeth I, munificently offered to restore the library at his own expense 'which then in every part lay ruined and waste'. This offer was gratefully accepted. Work progressed quickly, and the refitted and restocked Duke Humfrey's Library was formally opened on 8 November 1602.

When the single chamber of Duke Humfrey's was rapidly outgrown, Bodley funded an extension known as the Arts End. Importantly, he also provided an endowment to place the management and development of the collection on a secure financial footing. Today, the university library is named the Bodleian Library in memory of the energy and generosity of its founding benefactor, and thanks to his negotiations with the Stationer's Company, it is one of five copyright libraries in Britain that are entitled to receive a copy of every book published.

Space is a perennial problem, for which imaginative solutions have been found: the Radcliffe Camera was completed in 1749 to house scientific books; in the 1920s, a library extension capable of holding 5 million volumes was built across Broad Street; ten years later a bookstore was excavated beneath Radcliffe Square; recently, a new store was acquired in Swindon, allowing the tunnel linking the underground store to the main library to be refurbished as a reading room.

18. Schools Quadrangle

The Curriculum Set in Stone

Once Sir Thomas Bodley had completed his refurbishment of Duke Humfrey's Library, he embarked on a further project (which he could not fund himself but for which he could provide the driving enthusiasm) to replace the old and inadequate schools; sadly, Bodley did not live to see this work completed. The block of schools built in Schools Street by Osney Abbey and subsequently acquired by the university had been upgraded in the 1550s. Just fifty years later it was demolished to make way for a quadrangle which was to be the new focus for all university teaching.

The Schools Quadrangle (built in 1613–24) forms three sides of a court in front of the Divinity School and Duke Humfrey's Library. It is an imposing, even forbidding, structure of three storeys, battlemented, with its doors and windows set in the rigid symmetry of the Jacobean period. Its impressive five-storey gate tower is decorated with strapwork and foliage designs, and the paired columns at each level illustrate a different classical style. The sculpted panel is a piece of political flattery showing James I presiding over the schools while receiving honour from Fame and the university. Around the Quad, doorways lead into the different faculties, with the name of each 'school' or lecture room painted over the relevant door: Grammar, Logic, Rhetoric, Geometry, Arithmetic, Astronomy and Music (the seven 'liberal arts' of medieval study), Medicine, Law (Jurisprudence: its partner, canon law, had been discontinued at the Reformation), Greek and Hebrew Languages, Metaphysics, Natural Philosophy, Moral Philosophy and History. Theology, of course, was served by the Divinity School. If the Quad was in a sense backward-looking – an architectural statement of the traditional curriculum, which did not anticipate the emergence of new subjects – Bodley was far-sighted in other ways. In his will he left money for a third storey to be added above the schools' ranges to allow for the expansion of his library.

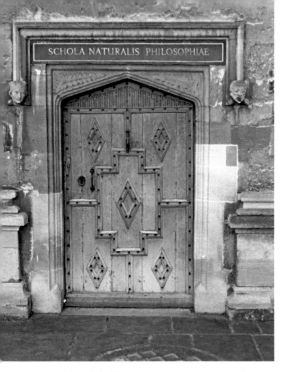
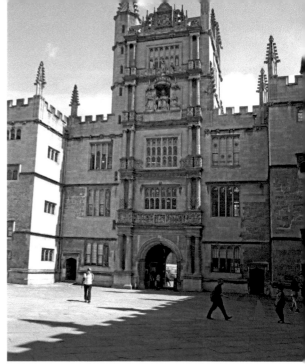

Above left: The doorways around the Quad each led to different Schools. This door originally gave access to the School of Natural Philosophy.

Above Right: The five-storey gate tower, each stage illustrating a different architectural style, dominates Schools Quad.

Below: A vaulted passage gives access through the north range from Clarendon Quad.

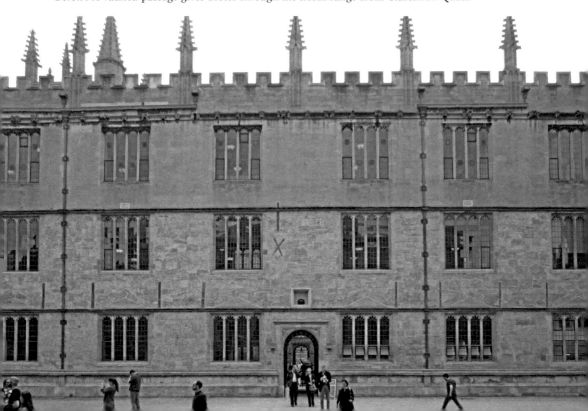

19. Gatehouse, Botanic Gardens

First Stirring of Botany

Henry Danvers, earl of Danby, was a career soldier. Probably inspired by the Jardin des Plantes, which had recently been established in Paris, in 1621 he donated a 5-acre site beside Magdalen Bridge to be used as a Physic Garden, though he failed in his attempt to engage John Tradescant, the king's gardener, to lay it out. The site included the long-redundant Jewish cemetery, a fact recorded on a plaque beside the main gateway. Unlike the scientific botanic garden it is today, its main purpose in the seventeenth century was as a source of medicinal plants for the Faculty of Medicine.

The site was enclosed by a wall, and Danvers engaged Nicholas Stone, a leading London architect, to design and build three gateways. Stone carried out his commission in 1632–33. The main gateway, giving access from the High Street, is a highly ornate triumphal arch in a generally classical style. It is a confection of pediments, columns and alternate bands of 'rustication', pierced by a tall carriage arch. Niches to either side now contain statues of Charles I and Charles II as Roman emperors, obviously later additions, while Danvers himself looks down from a niche in the main pediment. In contrast, the inner face of the gateway is restrained, lacking much of the rustication that characterises the outer face, but instead displaying eight now-empty niches. Stone's two other gateways were simple pedestrian entrances.

The outer face of the main gate, ornamented in classical style.

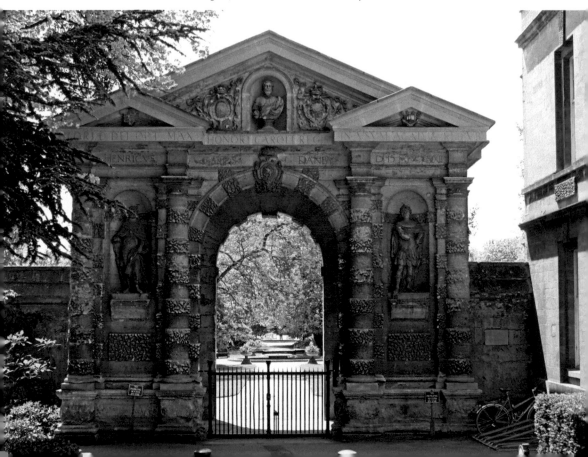

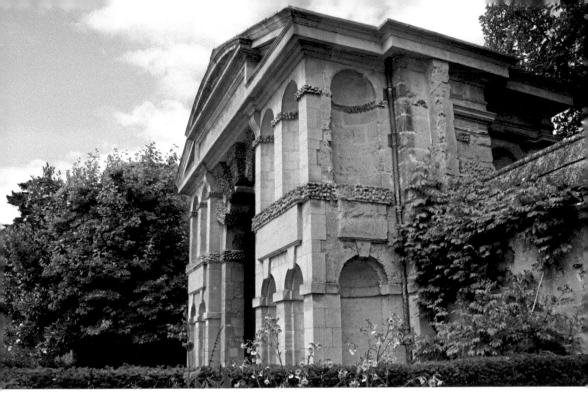

The simpler inner face of the main gate, with empty niches.

2c. Wadham College

New Colleges for a Secular Society

The peaceful accession of James I following the long and prosperous years of Elizabeth I's reign gave wealthy people the confidence to invest once again in the future. In Oxford, two new colleges were founded during James's reign: Wadham in 1610 and Pembroke in 1624. A wealthy but childless West Country landowner, Nicholas Wadham, sought to perpetuate his memory by founding a college. He died in 1609 before a stone had been laid, but his energetic widow, Dorothy, drove the project forward.

The 5.5-acre site of the former Augustinian friary just outside the town wall was acquired from the civic authorities for £600, and building was completed in 1613. The original college, what is now Front Quad, was erected in a single campaign and remains substantially unchanged. Three-storey ranges made efficient use of a small footprint. It houses most of the features that make up a traditional college: a gate tower and porters' lodge, chapel, hall, senior common room, accommodation, master's lodge; the final component, the library, was behind the hall. The Quad's Jacobean date is evident in its combination of Gothic style and classical symmetry, and its showpiece is a four-storey porch that slightly predates the grander example in the Schools Quad. The three prominent statues on the porch are of the founders, Nicholas and Dorothy Wadham, and James I.

Space is at a premium in central Oxford. The college has recently expanded to incorporate many of the eighteenth-century houses at the upper end of Holywell Street, which were previously let to tenants.

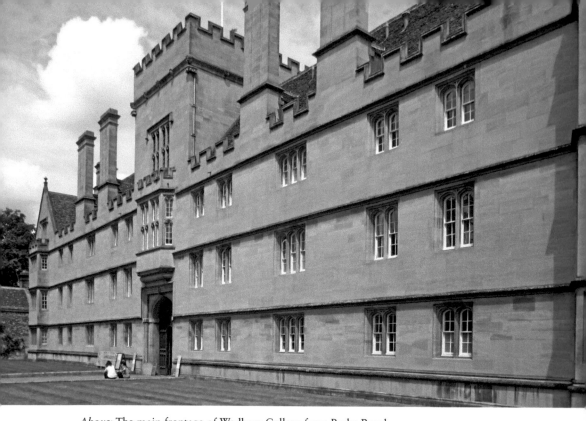

Above: The main frontage of Wadham College faces Parks Road.

Below: The ornate four-storey porch dominates Front Quad.

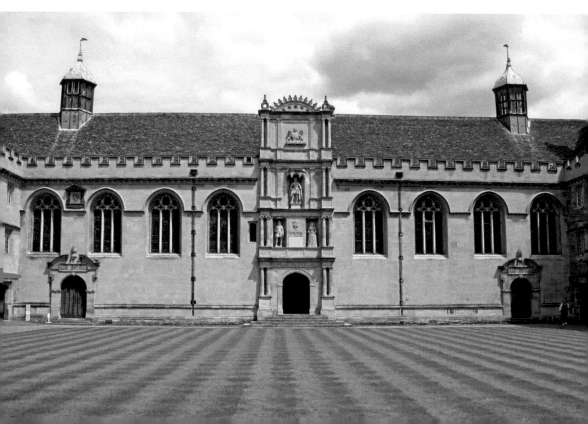

A glimpse of Front Quad through the main gate.

21. Civil War Mound in New College Garden

Oxford Under Siege

Charles I's challenge to the rising power of Parliament divided the nation and, in 1642, finally sparked civil war. At Oxford, the university was Royalist in sympathy while the town was more mixed. A militia of students and younger dons was formed, but was called away to join the king at Shrewsbury. Parliamentary troops were quick to occupy the undefended town. However, it was difficult to hold, so after disarming the townsfolk and seizing college silver, they withdrew. Following defeat at Edghill in October of that year, the Royalist forces in turn occupied Oxford and Charles made it his capital for the remainder of the war.

Both town and university suffered. The university emptied as students and fellows sought safety elsewhere; its wealth was seized and its buildings commandeered. The king lodged at Christ Church and the queen at neighbouring Corpus Christi. Magdalen Grove became a park for field artillery; a cannon foundry was established in Christ Church; Gloucester Hall was used for munitions production; the royal mint moved into New Inn Hall; Lincoln College housed the exchequer. Soldiers were billeted around the town.

Defence was a priority. The old medieval town walls were no match for artillery, so earthen ramparts were hastily thrown up while outworks guarded the two important bridges. The leading military engineer of the age, Sir Bernard de Gomme, was engaged to strengthen these rather makeshift defences. Colonel Fairfax, commander of the Parliamentary forces, was duly impressed as he dug in on Headington Hill anticipating a long siege.

In 1646, his support crumbling, the king was forced to surrender. The terms were reputedly negotiated in a house in nearby Old Marston now known as Cromwell House. In

The possible Civil War cannon mount in New College garden. (By permission of the Warden and Scholars of New College, Oxford)

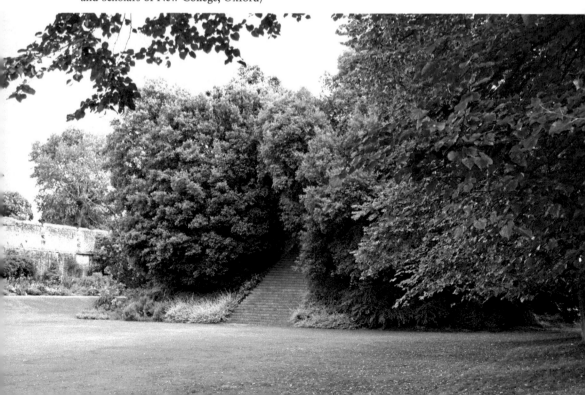

March 1647, the defences of Oxford were ordered to be 'slighted' to prevent their reuse. This slighting was so extraordinarily thorough that barely any trace remains. The most visible surviving fragment is a mound in New College garden which might perhaps have been an artillery platform, though in more peaceful times it was remodelled as a garden feature.

22. Sheldonian Theatre, Broad Street

A Dedicated Ceremonial Space

When the Protectorate petered out and Charles II came to the throne in 1660, the nation breathed a collective sigh of relief. For the university, this was expressed in a burst of new building projects. One priority was to create a grand new arena for its formal ceremonies, finally vacating St Mary's Church which it had used for over 400 years. The result was the dual-purpose Sheldonian Theatre, intended as both a venue for granting degrees and a theatre for plays. Remarkably, this apparently small building seats up to 1,000 people.

The Sheldonian, which embodies the very heart of the university, stands next to the Schools Quadrangle. It was the first architectural project of Christopher Wren, who was not yet the famous builder of London's St Paul's Cathedral but the Savilian Professor of Astronomy. Work began in 1663 and the Sheldonian was opened in 1669. Its model was the classical Theatre of Marcellus in Rome, hence the curved façade that faces the Broad. The white lantern of 1838 on the roof replaces an original. Inside, the grand auditorium includes a gallery, its wooden

The Sheldonian Theatre stands behind its statue screen, between the Old Ashmolean and the Clarendon Building.

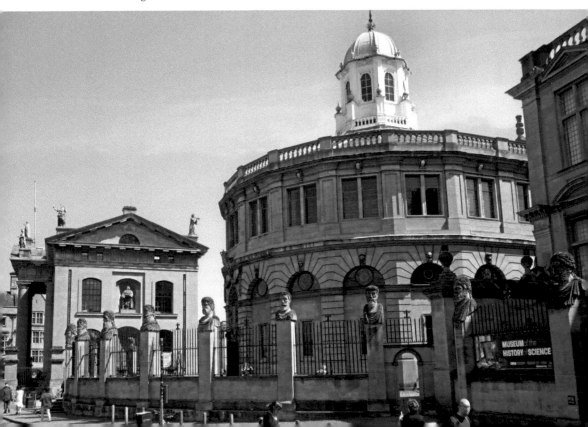

The rear façade of the
Sheldonian Theatre seen
from the Divinity School.

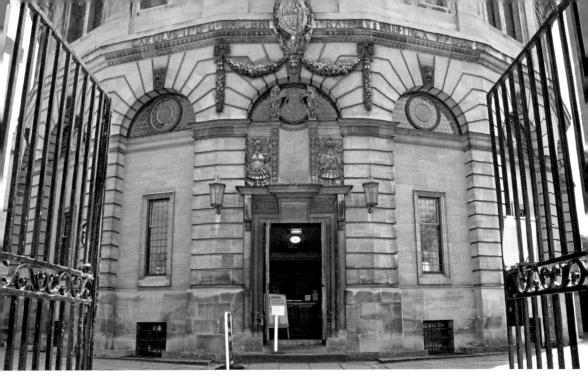

The curved front and main entrance of the Sheldonian Theatre.

columns painted to imitate marble, and the chancellor's throne. A classical theatre was open to the skies, a thing that was impossible in the British climate, so Wren adopted innovative technology to span the auditorium while a flat canvas ceiling painted by Robert Streeter created the illusion of a clear sky from which Truth descends with a supporting cast of allegorical figures. Wren's design had to be cut back to match the purse of the patron, Gilbert Sheldon, Warden of All Souls College and Archbishop of Canterbury, in honour of whom the building was named. Sheldon eventually parted with £12,239 plus £2,000 to set up a maintenance fund.

23. Old Ashmolean Museum, Broad Street

Stimulating Curious Minds

The seventeenth century saw the creation of the first purpose-built museum in Britain – and it is still a museum today. The gardening dynasty of John Tradescant and his son, also John, had assembled a famous collection after the fashion of their age, indiscriminately gathering together natural and man-made, ancient and modern objects – known as a gentleman's 'cabinet of curiosities'. John described it as 'those rarities and Curiosities which my Father had sedulously collected'. It opened to the public at Lambeth (London), and the help of Elias Ashmole was enlisted to produce a catalogue (published in 1656).

In 1677, John the younger passed the huge collection via Ashmole to the university. As there was nowhere to display such a prestigious gift, a special building was erected on the Broad next door to the Sheldonian, opened by the future James II on 21 May 1683. Surprisingly, there is doubt about its architect, who may have been the master mason Thomas Wood. In 1894, the collection was transferred to its present site on the corner of Beaumont Street. The Old Ashmolean now houses the Museum of the History of Science.

The Old Ashmolean Museum was opened in 1683.

24. Trinity College Chapel

A Gem of Restoration Architecture

Trinity College was founded in 1555 by Sir Thomas Pope, a lawyer in the service of the Crown. Pope bought the site of the dissolved Durham College, centre of study for the Benedictine Cathedral Church of Durham. The former monastic buildings were a ready-made college, so no new work was necessary and no lengthy and financially open-ended construction phase required. Today, only the old library of 1421 survives from the pre-Reformation institution.

In 1664, following the upheaval of the Civil War and the Protectorate, Ralph Bathurst was elected president of Trinity. (In those uncertain times, Bathurst had switched from the controversial subject of theology to the politically safer one of medicine). It was his ambition to rebuild the rundown college in a grand style. By the 1690s his scheme had reached the old monastic chapel. This was demolished and rebuilt, probably to designs by Henry Aldrich (dean of Christ Church and an amateur architect) with contributions from Christopher Wren. Bathurst himself contributed £2,000 to the project. The result was sumptuously baroque. Viewed from the south, the influence of Wren's post-Fire of London churches is evident. Large round-headed windows are separated by Corinthian pilasters, and the wall is topped by a balustrade supporting a row of flaming urns. Internally, it does not disappoint. With a floor of black and white marble, it is panelled throughout, the reredos is decorated with an intricate limewood garland carved by Grinling Gibbons, who also created the antechapel screens, and the ornate plaster and stucco work of the ceiling is embedded with painted panels by Pierre Berchet. Little has changed since its consecration in 1694: the stained glass is a gift of 1885, while the organ is twentieth-century. The architectural historian Nikolaus Pevsner eulogises, 'Trinity Chapel is one of the most perfect ensembles of the late C17 in the whole country'.

Above: Viewed across the lawns from Broad Street, Trinity College Chapel draws the eye.

Below: Large round-headed windows, Corinthian pilasters and balustrade show Sir Christopher Wren's influence.

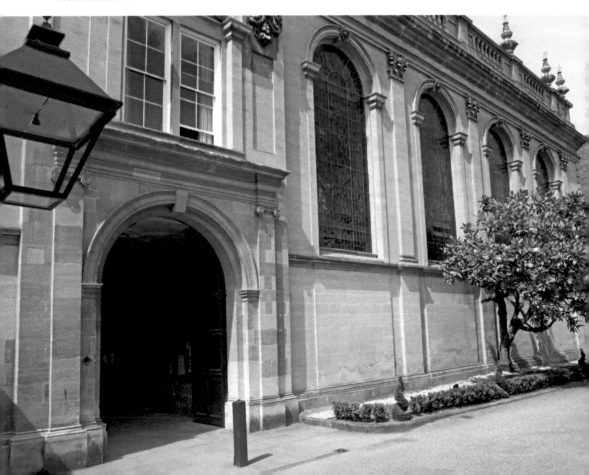

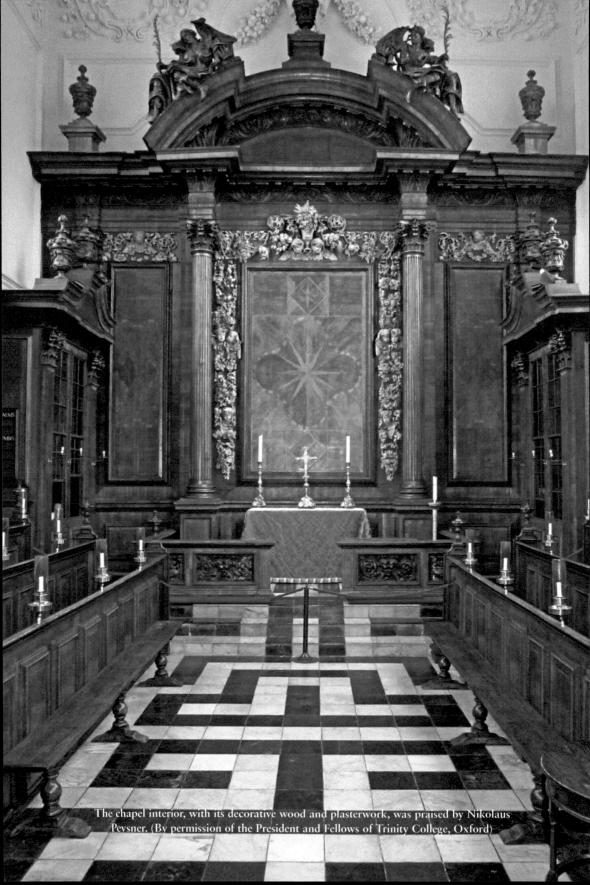

The chapel interior, with its decorative wood and plasterwork, was praised by Nikolaus Pevsner. (By permission of the President and Fellows of Trinity College, Oxford)

25. Stone's Almshouses, St Clement's Street

Charity and Self-Promotion

From the sixteenth century onwards, the care of the poor – particularly of the 'deserving poor' rather than the 'idle and indolent' – was a growing problem for the civic authorities at national and local level. The parishes of the town were each responsible for their own poor, the cost for which fell on their ratepayers. Here was an obvious social need, and private benefactors made often generous provision for the lucky few. In 1525, Cardinal Wolsey founded an almshouse in St Aldates, opposite the gate of his grand new college. Over the following centuries, others followed suit. One such was Edward Boulter who, in 1736, left money for an almshouse in the growing suburb of St Clement's for six 'poor, neat, honest men' to be chosen by the church wardens of the parish (their good character was as important as their poverty). In addition to a rent-free room and garden plot, each received a small income and a warm cloak. Unusually, his scheme included an adjoining house where an apothecary gave free medical attention to the sick poor.

A similar benefactor was Revd William Stone, whose bequest was used by his executors to establish Stone's Almshouses, where eight elderly widows each received a small stipend and an allowance in coal. This is a high-quality stone building of two storeys with four tenements on each floor and a committee room for the trustees. Over the central doorway, a cartouche displays the Stone arms above a plaque proclaiming, 'This Hospital for ye poor and sick was founded by the Reverend Mr William Stone, Principal of New Inne Hall, in hopes of thy assistance [i.e. donations from passers-by] Ao. Dni. 1700.'

Stone's Almshouses provided accommodation and an allowance for eight elderly widows.

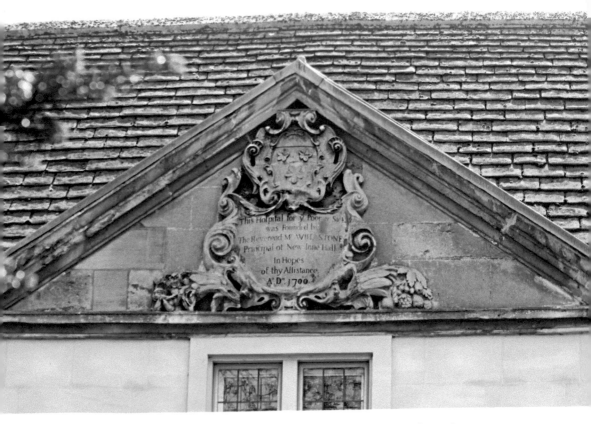

This Hospital for y Poor Sick
was Founded by
The Reverend M WILL: STONE
Principal of New Inne Hall
In Hopes
of thy Assistance.
A D. 1700

Above: Stone's coat of arms is a permanent reminder of his generosity.

Below: A committee room for the trustees was over the central passageway.

26. Clarendon Building, Broad Street

The University Press Comes of Age

The first book printed in Oxford was dated 1478, just two years after William Caxton had introduced the printing press to England, but this initiative was short-lived. The beginnings of the university press can be traced to 1584 when Joseph Barnes was lent £100 by Convocation to set up a printing press. At this time, printing was a London monopoly, but the university secured the right to maintain one printer and one press – although this first press was privately owned by Barnes who bore the financial risk. Barnes' successors proved too independent, so the Delegates of the Press was created in 1633 to oversee policy. After various 'arms length' experiments, the university eventually took full control in 1686.

When the Sheldonian Theatre was built in 1663–69, the Press was shoehorned into spare corners. Only when it reaped unexpected profits from the hugely successful *History of the Great Rebellion* by the Earl of Clarendon (published 1702–04) was the Press able to consider new premises. The result was the Clarendon Building of 1711–15, to designs by Nicholas Hawksmoor. The Press continued to expand, and in 1830 it moved to a new and much larger site in Walton Street.

The imposing Clarendon Building is designed in the classical style, two storeys tall with a semi-basement giving added height. From Broad Street, its central portico is approached up a flight of steps from which a vaulted passageway leads through the building to Clarendon

The Clarendon Building was designed in a classical style.

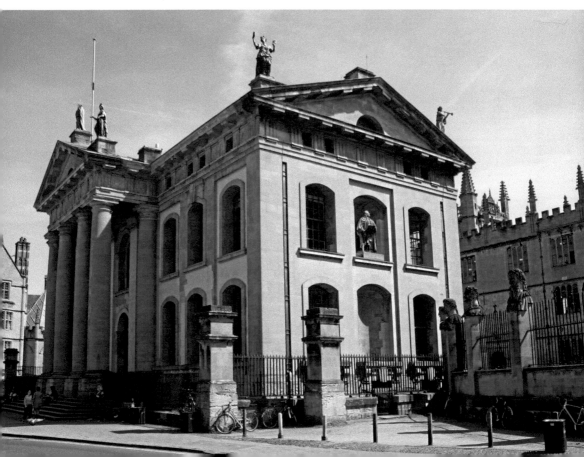

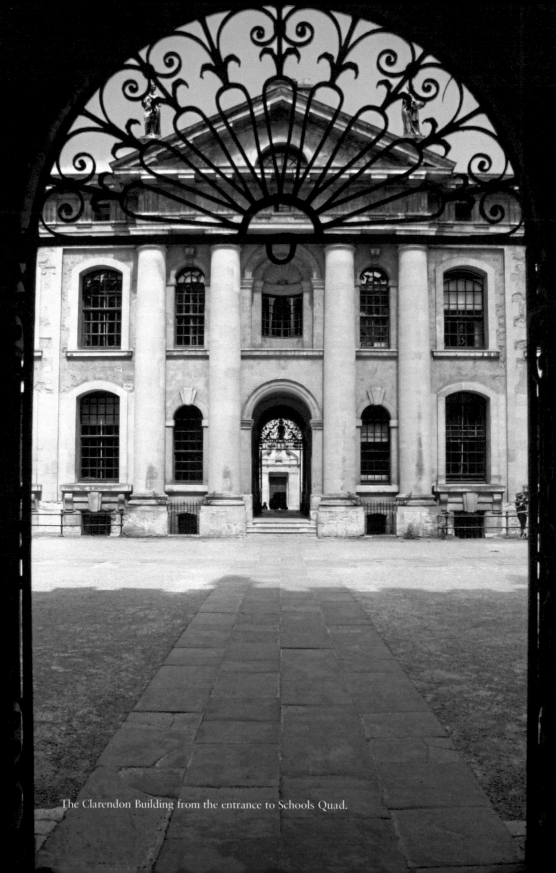

The Clarendon Building from the entrance to Schools Quad.

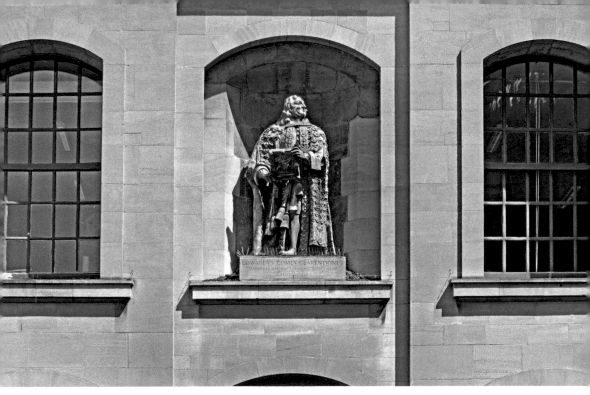

A statue of Lord Clarendon clutching his bestselling *History* is a reminder of how the building was financed.

Quad and the Schools. Statues of the Muses by Sir James Thornhill look out from the corners of the parapet, while in a niche at the west end Lord Clarendon clutches the book which made this building project possible. Today it gives the impression of being little more than a gateway to the treasures of Schools Quad and the Bodleian Library beyond.

27. North Quad, All Souls College

Eighteenth-Century Gothic

All Souls was founded by Archbishop Chichele in 1438, and Front Quad was built as a single unit in 1438–43, complete with the usual gate tower, chapel, hall, library and accommodation. By the turn of the eighteenth century, plans for a second quadrangle were in hand. North Quad is the conception of one man, Nicholas Hawksmoor, who learned his trade as assistant to both Sir Christopher Wren and Sir John Vanbrugh. After considerable delay, work began in 1716.

Hawksmoor favoured a Gothic style, taking his lead from the fifteenth-century chapel that formed part of the southern side of the quadrangle, and meticulously echoing its buttresses and fenestration in the Codrington Library, which faces it across the lawn – Christopher Codrington had left £6,000 to fund the library, which bears his name. The sundial over the library is said to have been designed by Christopher Wren while he was still Professor of Astronomy. A dining hall, kitchen and buttery complete the south range. The symmetrical and battlemented three-storey east elevation of the quad is dominated by a pair of extraordinary towers, which are Gothic at its most romantic. A screen closes the quad off from Radcliffe Square to the west.

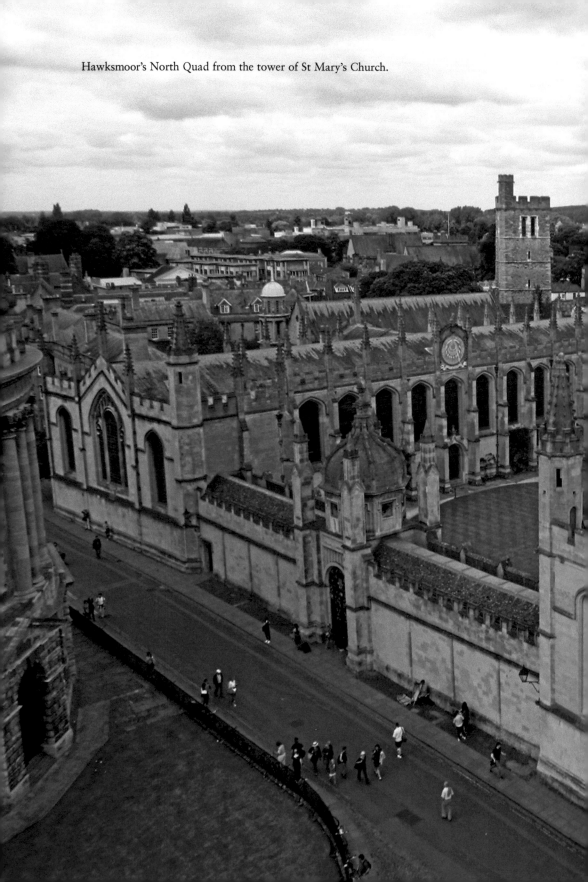

Hawksmoor's North Quad from the tower of St Mary's Church.

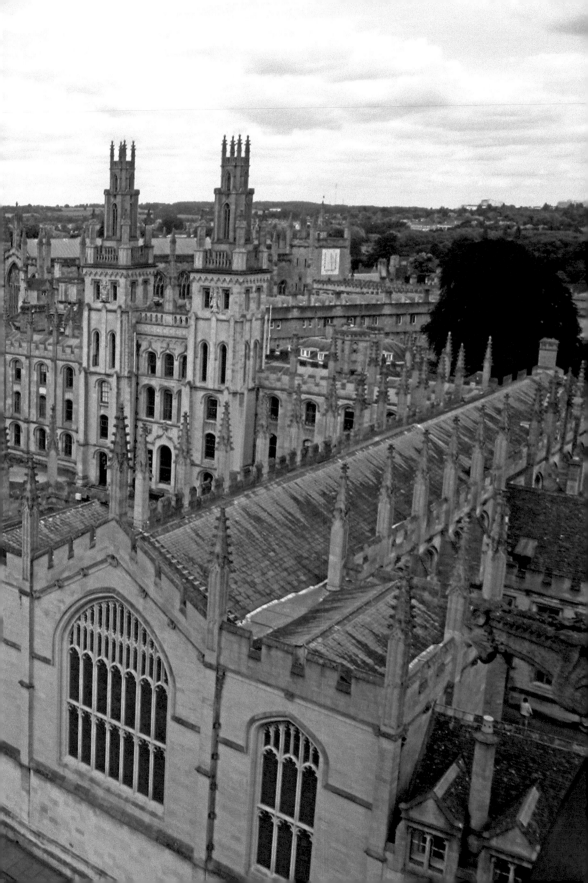

28. Holywell Music Room, Holywell Street

The First Concert Hall in England

Concerts and dances were important social occasions in the late seventeenth and eighteenth centuries, and many towns built assembly rooms as venues for their varied social life. Rather than following the fashion for assembly rooms, Oxford conceived the first purpose-built concert hall in England. The Holywell Music Room of 1742–48 cost £1,263 10s. Funded by public subscription, it was managed by a board of university men. Weekly performances continued until the 1830s when the popularity of concerts as social events declined.

The Music Room is intimate in scale, better suited to chamber music and recitals than a full orchestra. Possibly the brainchild of William Hayes, Professor of Music, its architect was an amateur, Thomas Camplin, Vice-Principal of St Edmund Hall. Set back from Holywell Street, its pedimented classical façade is reminiscent of a Nonconformist chapel. Inside, the impression is continued by a horseshoe of tiered seating facing a performance dais complete with enclosing rail and organ. Today, it is a valuable facility for the university's Faculty of Music as well as hosting regular public concerts.

The Holywell Music Room was England's first purpose-built concert venue.

29. Radcliffe Camera

A Generous Benefactor

One of Oxford's greatest benefactors was Dr John Radcliffe (1650–1714), and his name remains linked with the university's most iconic building. Radcliffe was an undergraduate at University College, moving on to a fellowship at Lincoln College. He became one of the leading physicians of his generation, in the process amassing a huge fortune. On his death Radcliffe bequeathed the bulk of his estate in trust to University College, his old college. Some was to be used for building projects within the college, and he established two medical travelling fellowships. Funds were also used to found the Radcliffe Infirmary (his name is still attached to the new hospital built on the edge of the city) to build the Radcliffe Observatory, used by the university until 1934 and now part of Green Templeton College, and to establish the Oxford Lunatic Asylum.

However, Radcliffe is best remembered for one further project. £40,000 was earmarked for building and managing a library – this is known as the Radcliffe Camera. The architect James Gibbs designed the building in the form of a classical rotunda. Externally, the ground-floor walls are rusticated. A ring of paired Corinthian columns at first- and second-floor level support the balustrade roof walk and the distinctive dome. Internally, the main

The Radcliffe Camera from the unusual vantage of the tower of St Mary's Church.

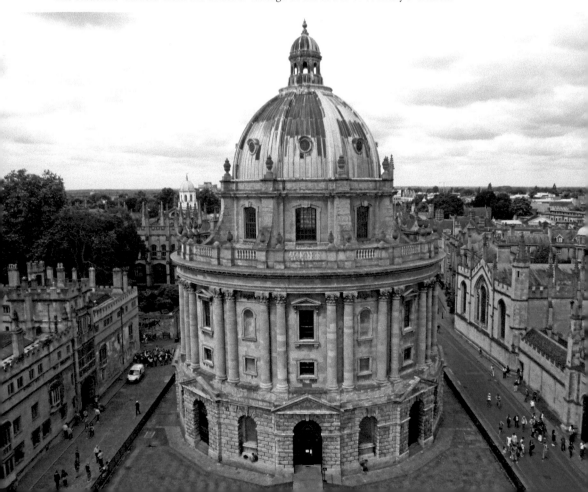

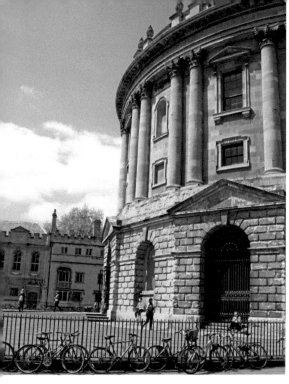

Left: The Radcliffe Camera remains one of Oxford's iconic buildings.

Below: A detail of the Radcliffe Camera.

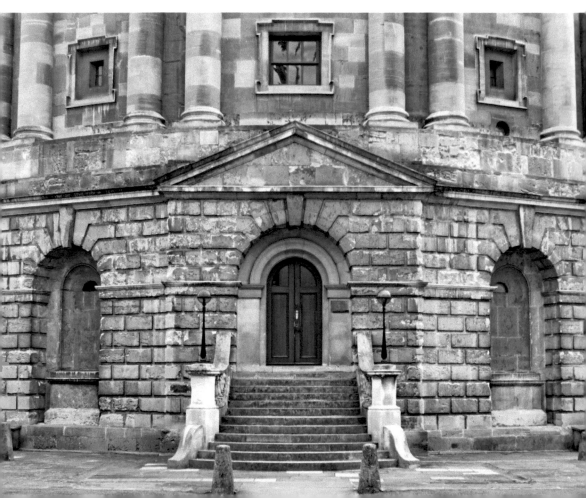

circular reading room rises into the dome, supporting a gallery. It was completed in 1749 and is still in use as a library.

At the close of Dorothy L. Sayers' novel *Gaudy Night*, Lord Peter Wimsey leaves Harriett Vane in pensive mood, enjoying the morning sun on the rooftop walk of the Radcliffe Camera: 'Harriet was left to survey the kingdom of the mind, glittering from Merton to Bodley, from Carfax to Magdalen Tower.' Sadly, access is no longer permitted.

30. Nos 33–38 High Street

A Normal Town

Many old houses and shops survive in Oxford, often buried within later buildings or behind updated façades. This unusual degree of preservation is in part due to the dominance of the university, which suppressed the wholesale development experienced in so many towns during the nineteenth century.

This picturesque run of early domestic and commercial buildings is sandwiched between All Souls and The Queen's College and faces University College, physically illustrating the interrelationship of town and gown. Largely timber framed, they date from the eighteenth, seventeenth and even sixteenth centuries. Today, at street level they are shops, though they may well have originated as the houses of wealthy townsfolk. Over the years they have been much altered and renewed, reflecting changes in both fashion and fortune, with new frontages and sash windows added to several in the Georgian period, and being divided and recombined as they gradually descended the scale from affluent

Sixteenth- to eighteenth-century shops and houses at Nos 33–38 High Street.

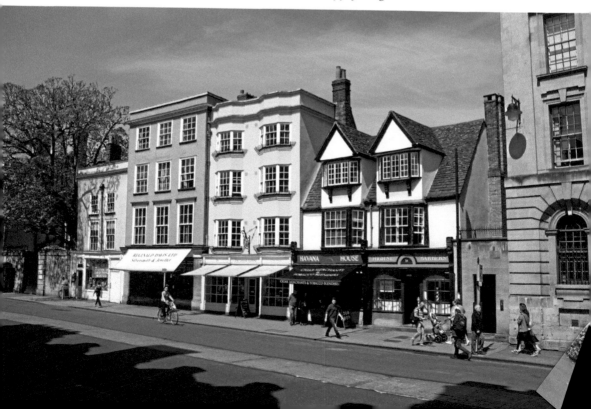

town houses to retail units with lodgings above. The building now numbered 37 and 38 is particularly attractive, with gabled dormer windows supported on carved wooden brackets of probable Tudor date.

31. Covered Market

Commerce and Civic Order

Saxon and medieval Oxford was primarily a market town like countless others, a town of artisans and traders, with stalls, small lock-up shops and workshops lining the main streets. Craftsmen and merchants dealing in particular goods tended to cluster together: for example, the top of the High Street was a shambles, known as Butchers' Street; St Aldates became known as Fish Street; Northgate Street became (and remains) Cornmarket; Broad Street was renamed Horsemonger Street. Other quarters were known for their vintners, mercers, cutlers and even goldsmiths. Two weekly markets crowded the High Street and overflowed into the side streets.

Oxford's annual St Giles' Fair still gives some impression of what market day may have felt like. For two days each September townsfolk throng the main road of St Giles which is closed to traffic and packed with stalls selling everything from roast chestnuts to imported jewellery to fairground amusements, as well as the usual drink and fast food.

In the late eighteenth century, the town authorities were under pressure to clear the streets of 'untidy, messy and unsavoury stalls' and other obstructions (including the town gates). The solution was to create a new, purpose-built market, with a monopoly on the sale of meat, fish, poultry, herbs and vegetables to ensure no street vendors could trade elsewhere. Their chosen site, known as the Covered Market, ran between Market Street and High Street. It was laid out on a grid pattern around four north–south aisles spanned

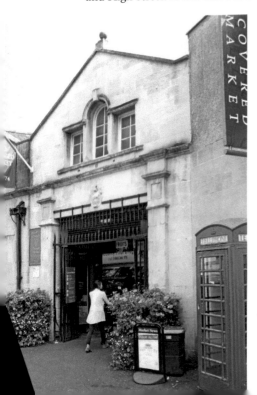

The entrance to the Covered Market from Market Street.

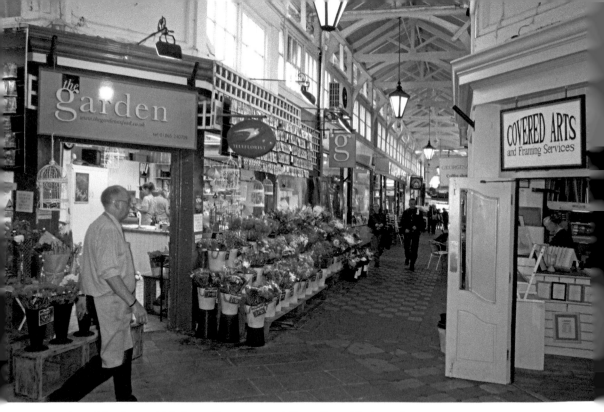

Above: The Covered Market still attracts specialist stalls and lock-up shops.

Below: The former Golden Cross Inn is now an entrance to the market.

by a lightweight glazed roof of timber and cast iron. A mix of lockable shop units, stalls and open standing was intended to suit every variety of trader. Construction was completed in two years from 1772–74, although during the following century the market was rebuilt and enlarged piecemeal by various architects.

The Covered Market still thrives today, with colourful stalls selling a range of artisan and specialist goods and foods. An additional entrance from Cornmarket cuts through the courtyard of the former Golden Cross Inn, parts of which date from the fifteenth century.

32. Folly Bridge

Crossing the Thames

St Aldates leads down to the ancient crossing point of the Thames that gave the town its name. Remarkably, archaeologists have found the ford and traces of wooden and stone causeways that allowed the Saxon traveller to island-hop across the broad and marshy river valley – progressive land reclamation has narrowed the river. This crossing was quite literally set in stone when Robert d'Oilly, the first Norman lord, built a stone causeway perhaps 700 m long, known as Grandpont, on the line of the old ford, making access to and through the town reliable at all seasons. The remains of d'Oilly's work are still buried within the modern roadway. An early bridge over the Cherwell on the site of the modern Magdalen Bridge was, by analogy, known as Pettypont.

A gate tower was built on the bridge in the thirteenth century, and the room above became known as 'Friar Bacon's Study' in the belief that it had been the laboratory of the

The present Georgian bridge stands on the site of the first Norman bridge.

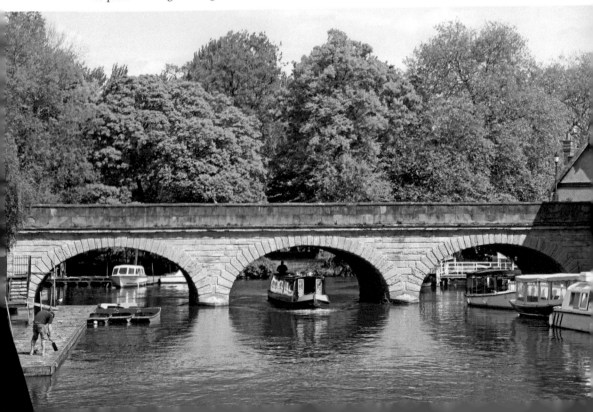

Above: Grandpont, d'Oilly's Norman bridge, included a causeway, which survives under the road.

Below: The former toll house is now a sweet shop.

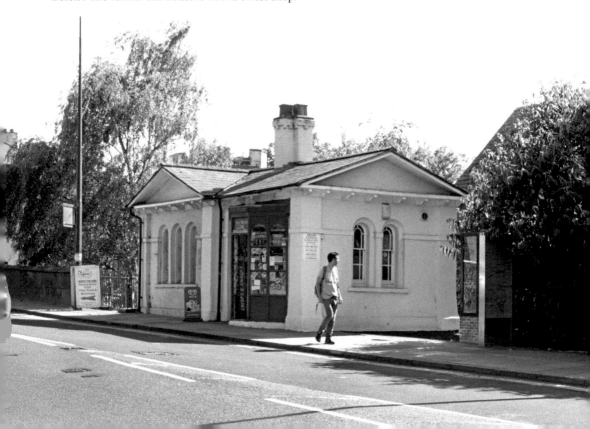

Franciscan Roger Bacon who is credited with being one of the earliest empirical scientists. It became a tourist attraction – the diarist Samuel Pepys paid the 1s admission in 1669. This famous tower was demolished to widen the carriageway in 1779 by the Hinksey Hill Turnpike Trustees.

By the start of the nineteenth century, the medieval bridge was in a dangerous condition, so was rebuilt in 1825–27 by the little-known architect Ebenezer Perry. In common with many bridges, it was a commercial venture and tolls were levied; it was freed from tolls in 1850. The former toll house, now a newsagent, still stands at the northern end of the bridge. Today, the Georgian bridge remains a heavily used component of the city's infrastructure, perpetuating the line of the ancient crossing.

33. Beaumont Street

Elegant Georgian Living

Henry I had a favourite hunting lodge at Woodstock, and Oxford, situated on an important crossing of the River Thames, was a convenient place to break the journey to and from London. A site was chosen just outside the walled town, beside the north gate, and by 1133 Henry's 'new hall', known as Beaumont Palace, was sufficiently comfortable for the royal court to celebrate Easter there, when thanks was offered for the safe birth of the future Henry II. It continued to be popular with royalty: the kings Richard the Lionheart and his brother John were both born here.

Late Georgian terraced houses in Beaumont Street.

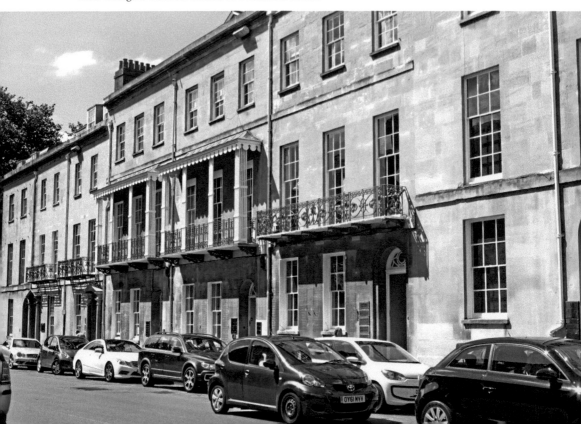

Right: A pair of Georgian doorways in Beaumont Street.

Below: Terraces in St John Street, part of the Beaumont Street development.

As fashions changed, royalty visited less often. Then, in fulfilment of a vow made at the disastrous Battle of Bannockburn in 1314, Edward II gave the now out-of-favour Beaumont Palace to the Carmelite Order. Following the Dissolution of the Monasteries, the buildings went into a slow decline as they were robbed for building materials. A drawing from 1785 shows some masonry still standing among the ruins; nothing of either palace or friary now remains. A workhouse occupied part of the former palace site in the eighteenth century.

In the late 1820s, terraces of elegant late Georgian houses, with fine ashlar frontages and ornamented with wrought-iron balconies, were laid out on the site of the old palace by St John's College, creating Beaumont Street and the less grand St John Street. These houses of quality enjoyed the relative space and peace of a suburban location despite being just a few paces outside the congested old town.

34. Jericho

A Workers' Suburb

Oxford, and particularly its poorer districts, was becoming increasingly overcrowded. However, expansion beyond the historic walls was slow to begin. One of the first working-class suburbs was the area known as Jericho, just half a mile to the north-west – a grid of streets lined with terraced houses running down from Walton Street towards the canal. This flood-prone district earned a reputation for poverty and poor drainage. Its Biblical name apparently derives from the seventeenth-century Jericho House inn which enjoyed the benefits of lying outside the town's jurisdiction.

The Jericho district was developed for workers' housing in the nineteenth century.

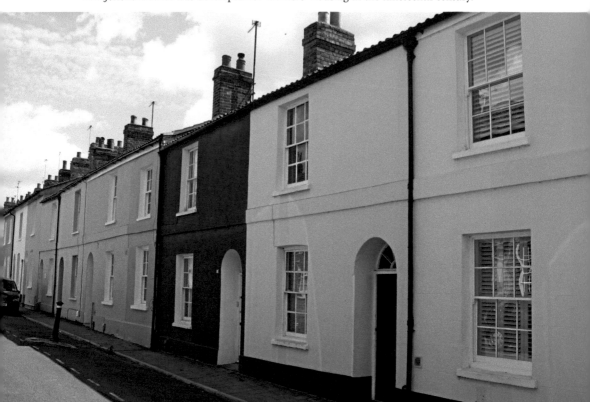

A small medieval farming community in the shadow of the town had long disappeared when workers' housing sprang up to service the Oxford Canal, which arrived in 1790. In 1812 the Eagle Ironworks was located here, attracting more workers. The transfer of the university press to new premises in Walton Street in 1830 spurred further rapid development. As the nineteenth century progressed, the suburb was extended when another much-needed block of working-class housing was laid out immediately to the north on the site of Tagg's Gardens, a former nursery garden on the west side of the Woodstock Road. Today the area has moved upmarket.

35. Park Town

Speculative Suburban Development

As late as the 1850s, Oxford really had no suburbs; the 1902–03 Ordnance Survey map still showed a small town tightly constrained between the rivers Thames and Cherwell. The ancient outskirts of Oxford clung to its walls: the Domesday manor of Holywell, the poor parish of St Thomas' established by Osney Abbey, the suburb along St Giles, the workers' housing of Jericho, even the Georgian Beaumont Terrace. From the mid-nineteenth century, the parish of St Clement's, across Magdalen Bridge, developed into a middle-class suburb just a short walk from the town centre.

St John's College had invested its endowment in a considerable area of farmland to the north of the town and, as the nineteenth century progressed, it looked for ways to increase its income. The college explored options for releasing this land in a controlled manner for exclusive development. To create the desired environment, streets were to be broad and leafy, villas were to stand in their own generous grounds, and materials were strictly controlled. The new church of St Philip and St James was to serve the new community. It proved more difficult than anticipated to find buyers, but the college was in no hurry.

A crescent of comfortable housing in Park Town.

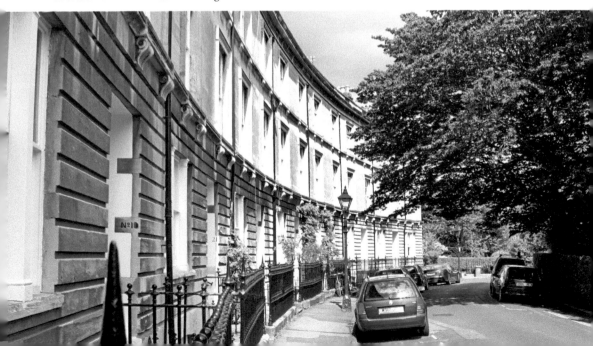

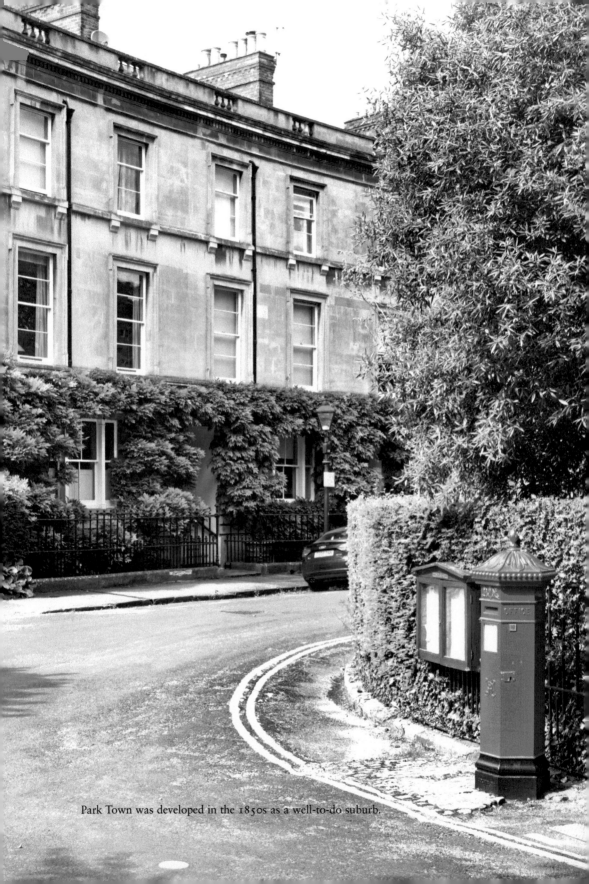

Park Town was developed in the 1850s as a well-to-do suburb.

A further terrace was added a few years later.

Leasehold plots were offered to speculative builders and limited companies. Slowly, housing developed along the Woodstock and Banbury roads towards Summertown, all still within walking distance of Oxford. Many of these large villas, often the homes of professional families, were individual designs in a Gothic or Italianate style. Today they are more likely to house university departments, or be divided into student accommodation.

One of the first developers was the builder Samuel Seckham, who established a limited company to finance the project. In the 1850s he laid out the exclusive Park Town estate, two elegant crescents of stone-faced Georgian-style houses around a central garden, together with some detached villas. A slightly cheaper crescent in brick and stucco was added a few years later. The neighbouring Norham Manor estate was created by different builders over the following decades. Penelope Lively suggests the houses here have 'tottered over the edge into madness'.

36. Keble College Chapel

Monument to Spiritual Renewal

The Oxford Movement, a religious renewal that began among a group of like-minded Oxford academics in 1833, went on to exert a huge and lasting impact on the Church of England. Its aim was to reinvigorate Anglicanism by restoring the High Church ideals of the late seventeenth century, and debate was stimulated by publishing a series of popular pamphlets or 'tracts' – hence its alternative name of Tractarianism. Its figurehead was John Henry Newman, an academic and vicar of St Mary Magdalen, who shocked the nation by

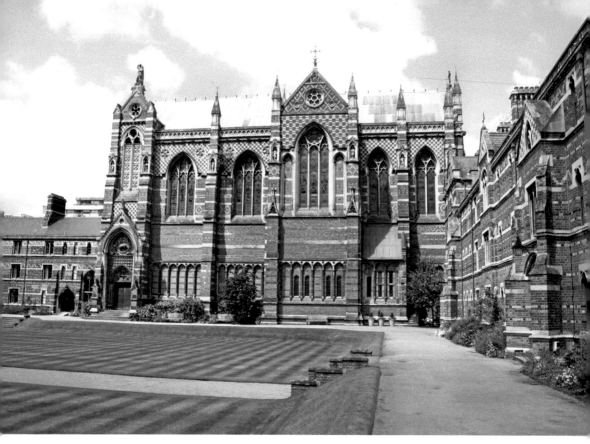

Keble College was founded in 1870 in memory of John Keble, theologian and poet. (With permission)

converting to Roman Catholicism in 1845 (and was later appointed a cardinal). Among the movement's other leading characters was John Keble, an academically capable yet self-effacing and devout man, vicar of Hursley near Winchester and Professor of Poetry at Oxford. His well-received book of devotional verse, *The Christian Year*, went through many editions.

Following Keble's death in 1866, an appeal was launched to found a college in his memory which, it was hoped, would serve as an unofficial High Church seminary. A plot was acquired on Parks Road and William Butterfield was engaged as architect. He designed the buildings quite conventionally around two quadrangles, though he deliberately broke with the Oxford tradition of reserved, stone-clad colleges. Instead, he built in red brick, relieved with bands, chequers and trellises in white stone and coloured brick. The result is striking, provoking unflattering comments from critics at the time, and his style has continued to go in and out of favour.

The chapel was to be the heart of the new college; it alone cost £50,000, paid for by a donation from William Gibbs of Tyntesfield, near Bristol. It is astonishingly tall, towering over the rest of the quad, and continues Butterfield's controversial surface treatment. Inside, it is richly decorated with mosaic panels, stained glass and ornately carved stonework beneath a rib-vaulted ceiling. A side chapel was built in 1892 to house the famous painting of Christ as *The Light of the World* by Holman Hunt – or, one of them, as the artist made a copy which hangs in St Paul's Cathedral!

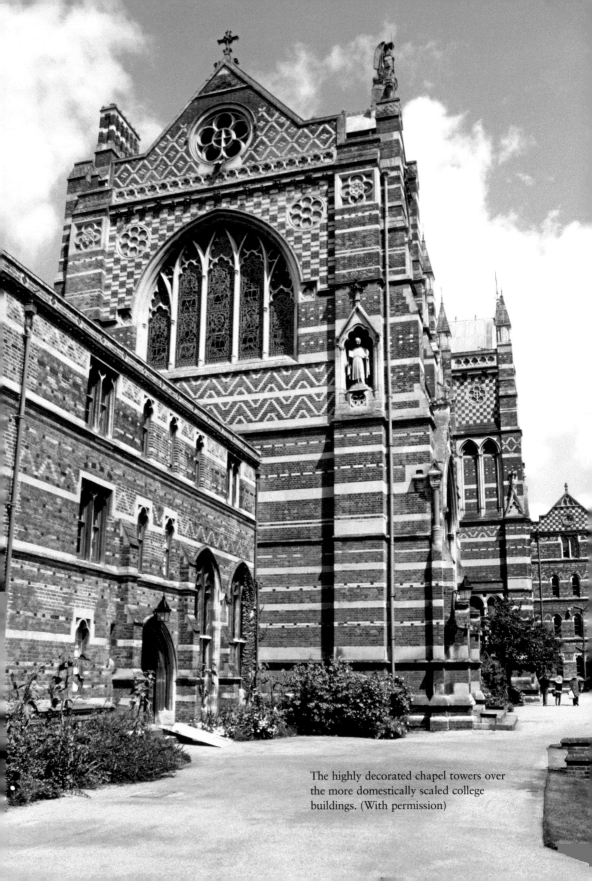

The highly decorated chapel towers over
the more domestically scaled college
buildings. (With permission)

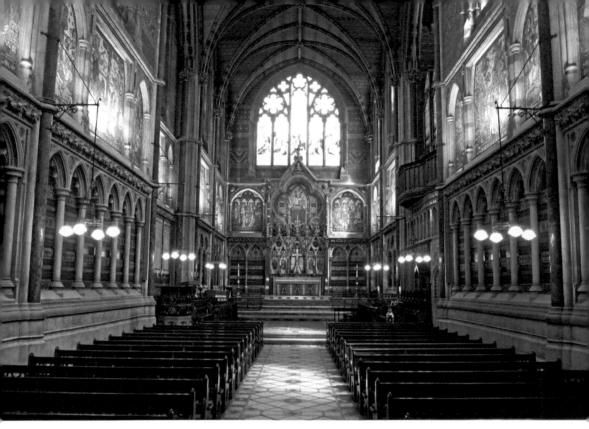

Inside, the atmospheric chapel is spacious and richly decorated. (With permission)

37. Ashmolean Museum

Art and Antiquities

When the important collection of classical marble sculpture assembled by Thomas Howard, 2nd Earl of Arundel, was donated to the university in 1755, it proved something of an embarrassment as there was nowhere suitable for its display. In the absence of a dedicated space – the Old Ashmolean was too small – it was placed alongside the growing art collection in the Bodleian Art Galley until a more appropriate venue was found.

Sir Robert Taylor's substantial bequest to establish an institute to teach European languages was languishing unused, and, by creatively combining this bequest with others, the university was able to begin planning for a new art gallery. A design competition for a joint art gallery and institute was won by Charles Robert Cockerell in 1839. Cockerell's classical design consists of two projecting wings, with that to the right housing Taylor's institute and, in the centre between them, an impressive portico of Ionic columns. Inside, the entrance hall is defined by screens of columns.

The art and sculpture collections were moved into the new building in 1845. The archaeological collection, the core of which was still the Tradescant collection donated by Elias Ashmole, only followed in 1894. These two collections were not formally integrated to create the Ashmolean Museum of Art and Archaeology until 1908.

The building was extended in the 1930s as collections expanded. Then, in 2001, Rick Mather Architects was commissioned to give the Ashmolean a contemporary look,

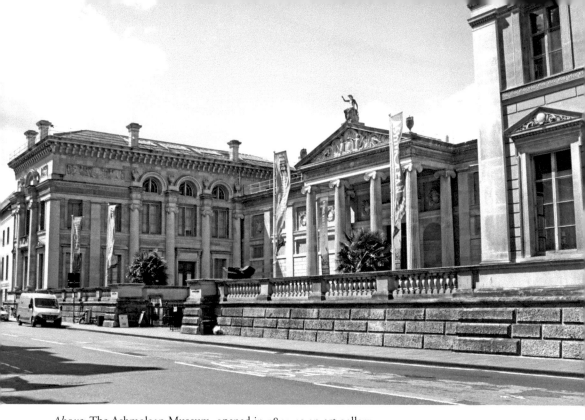

Above: The Ashmolean Museum, opened in 1845 as an art gallery.

Below: Detail of the portico over the main entrance.

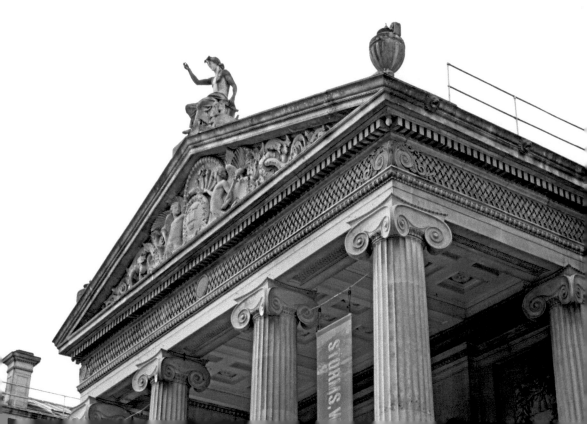

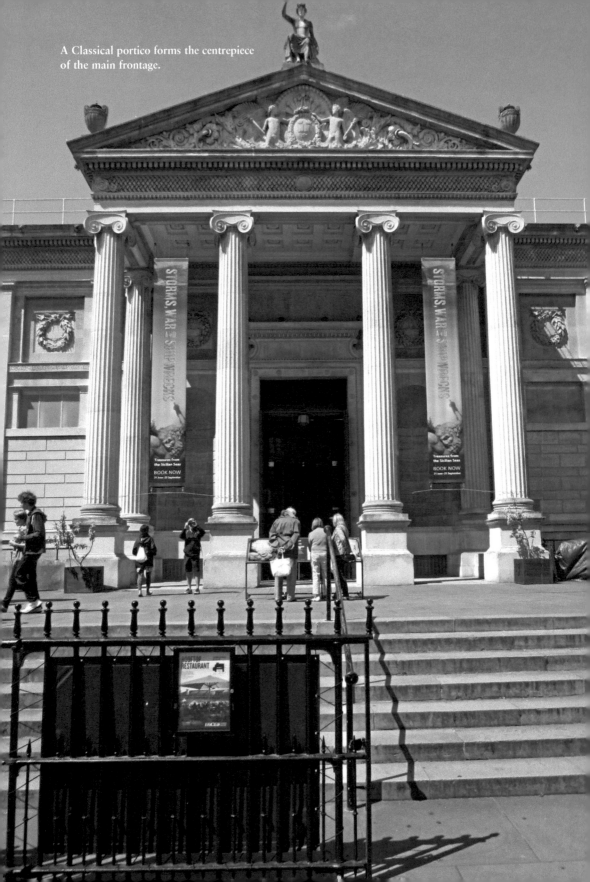

A Classical portico forms the centrepiece of the main frontage.

adapting and enlarging the existing building. At the same time, the opportunity was taken to modernise the visitor experience by developing a radical new display based on cross-cutting themes rather than the traditional regions and periods.

38. Wesley Memorial Methodist Church, New Inn Hall Street

John Wesley's Legacy

One of the prominent marks of the Oxford skyline is the spire of the Wesley Memorial Methodist Church. Methodism traces its origin to Oxford, where its future founder, John Wesley, won a scholarship at Christ Church in 1720, followed a few years later by his brother Charles who was to become a prolific hymn writer. John was ordained deacon in the Church of England and in 1726 was elected to a fellowship at Lincoln College. He discovered a new spiritual seriousness and, together with Charles, led the Holy Club, an informal group who met to study the Bible. He went on to travel thousands of miles on horseback, preaching all over the country, often in the open air.

Yet John never intended to break away from the Church of England; that step was forced upon his followers by prejudice and ridicule. Methodists suffered persecution; for example, in 1768, six students were expelled from St Edmund Hall simply for being Methodists. It was only with the repeal of the Test Act in 1871 that non-Anglicans, including Methodists, were admitted to the university.

The church, with a former Georgian rectory (now part of St Peter's College) to the left.

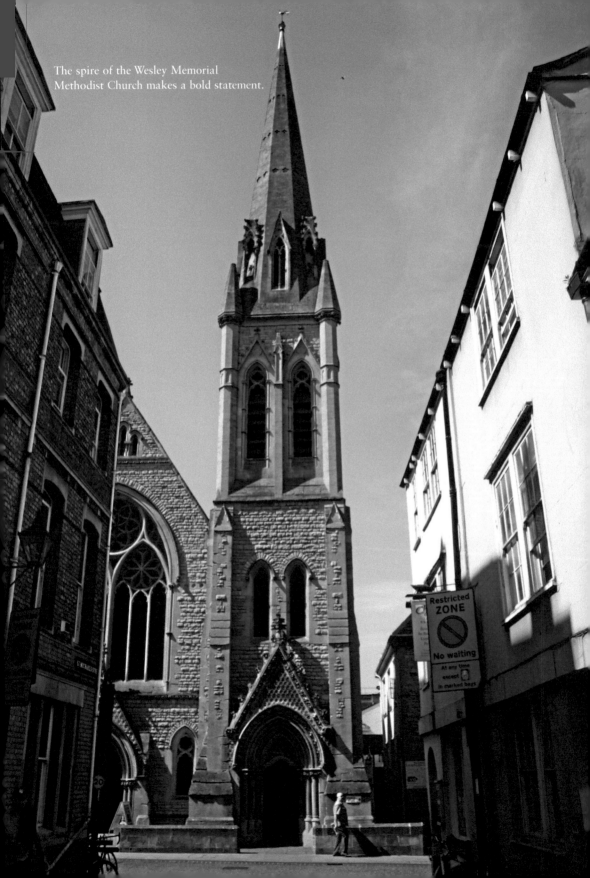

The spire of the Wesley Memorial
Methodist Church makes a bold statement.

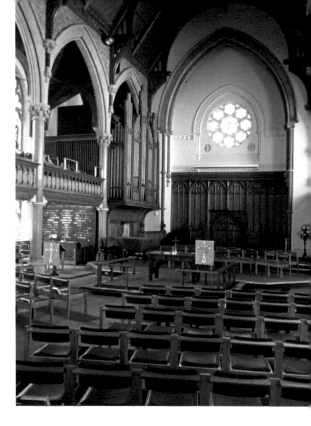

The Victorian Gothic interior of the church.

In Oxford, a following was attracted from both university and town, meeting first in private houses, then in rented rooms. A plaque on the wall of Nos 32–34 New Inn Hall Street proclaims, 'On the 14th July 1783 and on several subsequent occasions John Wesley preached in this building, the first Methodist meeting house in Oxford.' The new movement soon sought their own purpose-built chapel (since demolished), which was built in 1818 a little further down the street.

In time, this first chapel became too small for its growing congregation, so it was decided to build a new church. This was to make a bold architectural statement about the place of Methodism in the town, made easier following the repeal of the Test Act. The substantial Wesley Memorial Methodist Church was designed by the architect Charles Bell in the Gothic style of many contemporary Anglican churches. Standing unashamedly on the frontage of New Inn Hall Street, its doors opened in 1878.

39. University Museum of Natural History, Parks Road

Science Finds a Home

In an age of industrial and commercial power, Oxford and Cambridge universities were perceived to be irrelevant and outdated, and were notoriously slow to respond to social and cultural change as the Royal Commission of 1850 documented. An example was the way in which science was treated. The first scientific laboratories had been squeezed into a thoroughly inadequate space in the basement of the Sheldonian Theatre. Further rooms were found in the neighbouring Clarendon Building when Oxford University Press moved out in 1830; the facilities remained thoroughly inadequate.

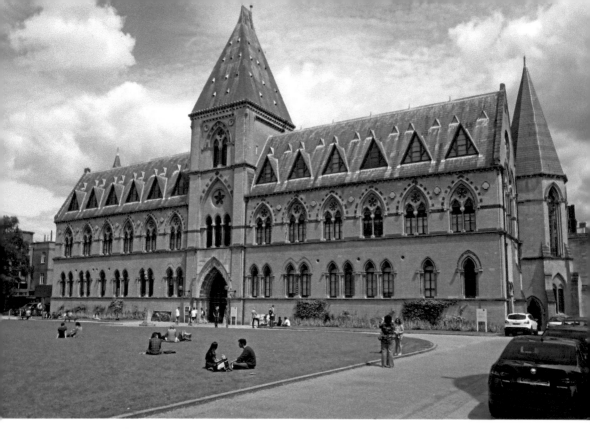

Above: The University Museum of Natural History opened in 1860.

Below: Among the museum's best-known exhibits are its dinosaur skeletons.

A column commemorating the debate on Darwinism between Wilberforce and Huxley stands on the forecourt.

Dr Henry Acland, Reader in Anatomy, helped make the case for a new institution to serve both as a space for science teaching and a museum. A significant part of its role would be to gather examples of plant and animal life from around the world for use as teaching aids. In the atmosphere of the times, approval was readily granted. Plans progressed quickly, and the museum opened in 1860. It is an imposing structure, consciously echoing ecclesiastical architecture to stand as a cathedral to science. Internally, Gothic columns and pointed arches combine with state-of-the-art materials such as cast iron and glass. The huge main court, measuring 33 m by 33 m, is spanned by a glazed roof and surrounded by a cloister and gallery. No opportunity to educate the visitor was missed. Each column is a carefully labelled example of a different British rock, while the capitals are carved with botanically accurate plants. Appropriately, it was the venue in June 1860 for the defining debate between Samuel Wilberforce, Bishop of Oxford, and T. H. Huxley about the implications of Charles Darwin's book *Origin of Species*, an event which is commemorated by a sculpture in the forecourt.

Today, science has outgrown one building, and the museum is perhaps best known for its dinosaur skeletons and its stuffed dodo, a flightless bird that has been extinct since the seventeenth century.

4c. Somerville College, Woodstock Road

Female Students at Oxford

Until 1878 only male students could study at Oxford, but in that year an enlightened proposal was approved to create an academic hall where young women could experience higher education, although female students were not admitted as full members of the university until 1920. The Association for the Higher Education of Women was established to take the project forward. Lady Margaret Hall was promptly founded in a large house in Norham Gardens. Initially it had been thought that a single hall would be sufficient,

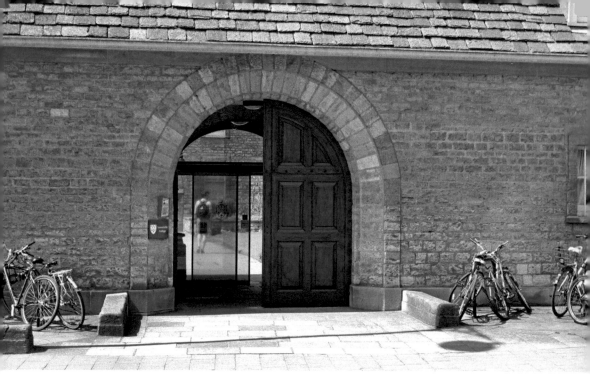

The University of Oxford first admitted female students in 1878. Somerville College was founded the following year.

but Lady Margaret Hall was strictly Church of England and it was realised that a second, non-denominational, hall was needed. Somerville was founded the following year in a large house on Walton Street. Two more women's halls followed: St Hugh's in 1886 and St Hilda's in 1893. All four were safely located in the leafy and respectable suburbs. These institutions were all granted the status of colleges in 1959.

At the same time, a different model was tried out, following the pattern trialled by the Delegacy for Non-Collegiate (male) students established ten years earlier. The Society of Oxford Home Students was set up in 1879 to coordinate female students living in private houses in the town. This became the St Anne's Society in 1942, and a full college within the university in 1952.

Somerville was named in honour of the Scottish mathematician and scientist, Mary Somerville. Tucked away behind St Aloysius' Church and the private housing fronting Woodstock Road and Little Clarendon Street, its nineteenth- and twentieth-century buildings, including the original Walton House, overlook a surprisingly spacious lawn. Only in 1934 were a new quad and gateway built to provide formal access from Woodstock Road.

41. Jam Factory, Park End Street

A Monument to Marmalade

Frank Cooper took over the family grocer's shop at No. 83 High Street. Obviously an entrepreneur, he soon expanded into No. 84. In 1874, he began to market marmalade made by his wife, Sarah-Jane, to her own recipe using Seville oranges. This proved popular, and Cooper's Oxford Marmalade soon became a British breakfast tradition, even being

Above: The former factory for Cooper's Oxford Marmalade.

Right: The waggon entrance to the works, with its ornately carved lintel.

a necessity on Captain Scott's ill-fated expedition to the South Pole. It continued to be made behind the shop until 1903, when the business moved to a purpose-built factory in Park End Street. At four storeys tall, these new premises show how far demand had grown. Designed by the Oxford architect Herbert Quinton, they are eye-catchingly eclectic – what is termed 'Free Style' – with alternating bands of red brick and pale stone, while the lintel above the central waggon entrance is carved with a plant scroll motif. The earlier family business was not forgotten, and the grocery shop was relocated to the street frontage.

The new factory was ideally located for distribution, just across the road from the GWR and LNWR stations that stood side by side. In the 1960s, production was transferred to a larger site in Oxford before the firm was bought out – but the famous name was retained. Today, a blue plaque marks Nos 83–84 High Street, while the building in Park End Street, now renamed the Jam Factory, is an arts centre and restaurant.

42. Examination Schools, High Street

'For the Torture and Shame of Scholars'

As undergraduate numbers increased during the late nineteenth century, it became clear that existing exam facilities were inadequate. Despite this, the new Examination Schools were mired in a philosophical debate between those who saw the university's future in

Vast areas of glazing dominate the High Street frontage.

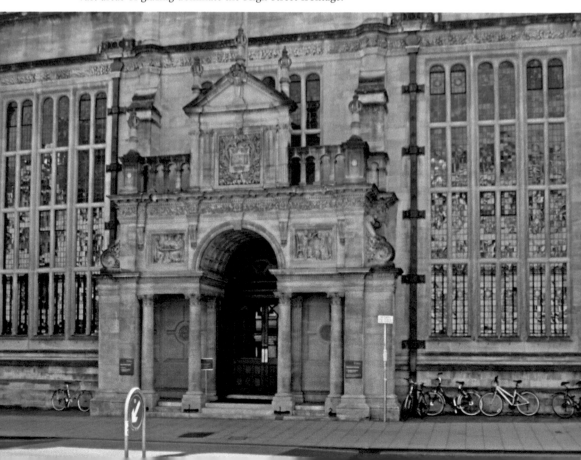

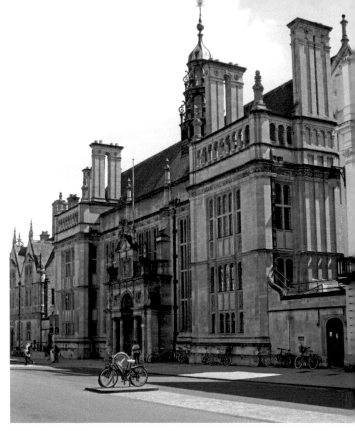

Right: T. G. Jackson designed the Examination Schools in a radically new Elizabethan-Jacobean style.

Below: The main courtyard of the Schools sits under the eye of a clock.

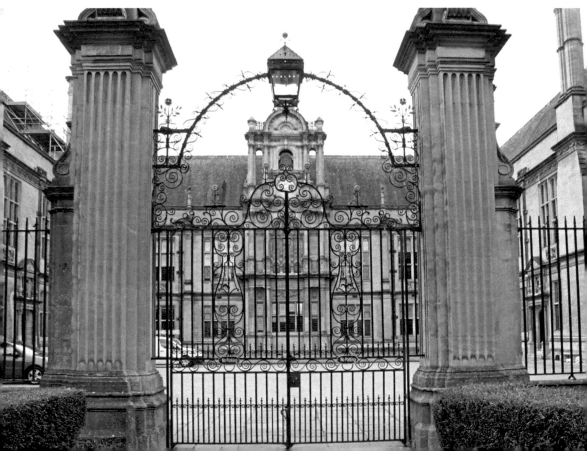

undergraduate teaching (and therefore in examinations), those who believed that the university should be predominantly a postgraduate research institution, and those entrenched conservatives who resisted change. These philosophical differences were played out in architecture.

A first, restricted architectural competition was inconclusive; a second competition was won by T. G. Jackson. When the schools opened in 1882, they were a triumph for the modernisers, representing a break from the backward-looking Gothic style that had dominated the university for a generation. In its place, Jackson introduced something new and fresh, an eclectic English Renaissance, a re-envisioning of Elizabethan and Jacobean design – described by some conservatives as a 'profanation'. This was also the first building in Oxford designed by Jackson and may be said to have established his career. He went on to stamp his mark firmly on both town and university through many other projects.

The Examination Schools is built around three sides of a courtyard which opens onto Merton Street. Huge windows seem to fill the main High Street façade, the central bay is distinguished by an ornate porch behind which the entrance hall is open to the hammer beam roof, while the building is topped with an essentially redundant louvre turret. It is finished with marble and mosaics throughout. On the first floor are the huge North and South Schools where each year thousands of students sit their exams dressed in 'sub-fusc', the formal attire of dark suit and white bow tie, gown and mortar board, and perhaps a floral button hole, which tradition still requires when a gentleman sits a university examination.

43. Town Hall, St Aldates

Civic Pride Asserted

This spot has long been the seat of local government. The present town hall stands on the site of the medieval guildhall of 1292 and its replacement of 1752. The Georgian building became too small to accommodate growing civic pride, so an architectural competition was announced in 1891 for a new town hall. The winner was Henry T. Hare, whose design was realised in 1893–97 at a cost of over £94,000 (against an estimate of £50,000). His main elevation on St Aldates, built in Clipsham stone in a Jacobean style, is near-symmetrical despite the difficulties of the plot.

A lot of effort was invested in impressive interior decoration with ornate plasterwork throughout. A grand staircase leads up from the large entrance hall to the public rooms on the first floor. The largest of these is the Main Hall, which is regularly used for concerts and is hired out for private functions. However, during the First World War it 'did its bit' as a military hospital, specialising in malaria cases. At its apsidal eastern end, an organ by Henry Willis & Son (built 1896–97) stands on a stage which can hold up to 200 performers. A gallery surrounds the hall on the other three sides. The barrel-vaulted ceiling and gallery fronts are richly plastered, and coats of arms inject a vibrant dash of colour while proclaiming the town's important affiliations, perhaps in an attempt to outshine the armorial university. The spandrels (the space between the arches) are ornamented with allegorical figures by Frederick E. E. Schenck depicting such subjects as industry. The whole conveys the intended impression of civic prosperity.

A new town hall was required in the late nineteenth century to accommodate growing responsibilities.

44. Bridge of Sighs

A Picturesque Solution

Hertford College is a tale of slow decline, death and rebirth. It began life by 1282 as Hart Hall, one of the university's many academic halls. Despite being desperately poor, it managed to hang on while the rising colleges caused most of its rivals either to close or amalgamate.

The original Hart Hall stood on the south side of New College Lane and fronted Catte Street; its sixteenth-century dining hall survives. The site was very cramped, though space was found by acquiring neighbouring tenements and halls. In 1740, due to the exertions of Principal Richard Newton, it was granted the status of a college within the university. If Newton had hoped this would secure its future, he was to be disappointed as the finances became increasingly fragile. Eventually, no one could be found to fill the post of principal and the college was dissolved. Then, in 1820, the poorly maintained college buildings collapsed into the road. Another of the old academic halls, Magdalen Hall, was quick to relocate to the now-vacant site when it was displaced by its much larger neighbour, Magdalen College. It soon became the turn of Magdalen Hall to seek college status in order to shore up its position. Its fortunes were turned around by a substantial donation in 1874 from the banker Sir Thomas Baring, and an Act of Parliament refounded the institution under the former name of Hertford College.

In 1898 the college expanded across New College Lane, and the prominent architect T. G. Jackson was engaged to build or rebuild most of the college buildings. Apart from

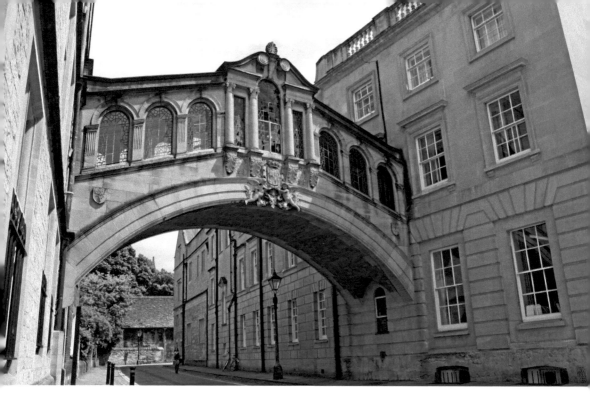

The Bridge of Sighs links the two halves of Hertford College.

retaining an octagonal chapel of around 1520, an entire new quad was built. The two halves of the college were then linked by a bridge spanning New College Lane. This bridge, one of the iconic sights of Oxford, was built immediately before the First World War. It is imaginatively named after the famous bridge in Venice, the Bridge of Sighs (although it looks more like the Rialto Bridge). Renaissance in style, all glazing and displaying the college arms, it is entirely dissimilar to the buildings on either side.

45. Eagle & Child, St Giles

A Writers' Tavern

A suburb grew up outside the north gate of the town in the twelfth century, served by the church of St Giles. Many of the buildings which front the wide street date from the seventeenth century. The timber-framed Eagle & Child is no exception, sandwiched between neighbours of similar date, and has been a public house for most of its life. It would be just one of several pleasant old inns, were it not for two well-known regulars whose portraits still adorn the walls.

The University of Oxford has produced many eminent academics over its long history, of whom a handful live on as household names. The Inklings was an informal literary club that met weekly during the 1920s and 1930s over a drink, often in the Eagle & Child. Its two most famous members (although there was no membership as such) were C. S. Lewis and J. R. R. Tolkein, both leading academics who shared an interest in early English languages and literature and a Christian faith. Lewis was a fellow of Magdalen College and an internationally renowned scholar of medieval English literature before becoming

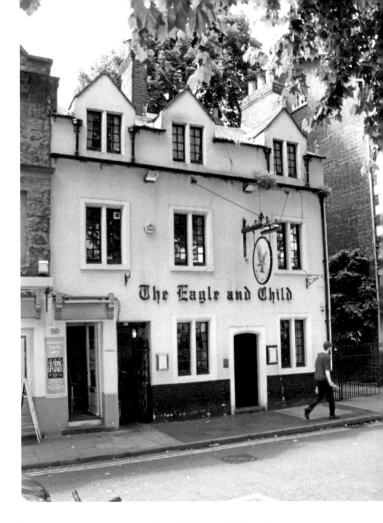

This seventeenth-century tavern was a favourite haunt of the Inklings.

Professor of English and Medieval Renaissance Literature at Cambridge. He is best known today for his *Chronicles of Narnia* series and his writings on popular theology. Tolkien was elected Professor of Anglo-Saxon at Oxford. Despite his academic reputation, he is best remembered for his children's story *The Hobbit* and for the *Lord of the Rings* trilogy, which drew on his scholarly knowledge.

46. College Boathouses

Healthy Bodies, Healthy Minds

By the mid-nineteenth century, the importance of sport ranked alongside academic study in forming the character of the young men who were to go out from the university to run the empire. It still has a high profile today. The university Boat Race between Oxford and Cambridge was first rowed in 1829 and the Oxford University Boat Club was founded with the sole objective of winning this annual event, although the club does now compete in many other regattas.

Rowing is firmly established as one of the university's most prestigious sports and continues to be popular with undergraduates at all levels of ability despite the training

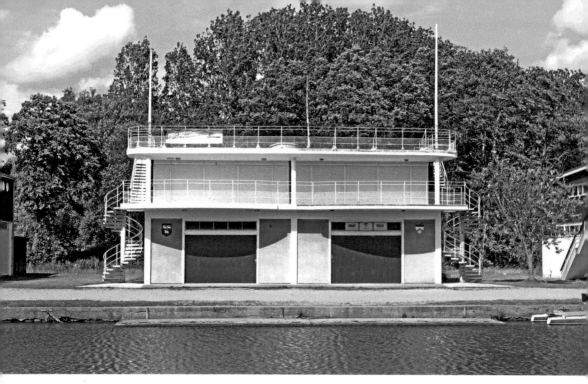

Above: One of several college boathouses on an island in Christ Church Meadow.

Left: The upper floors are designed for viewing the river.

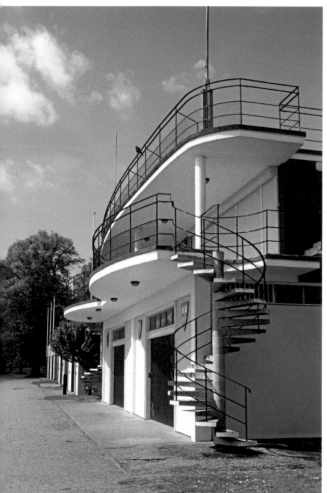

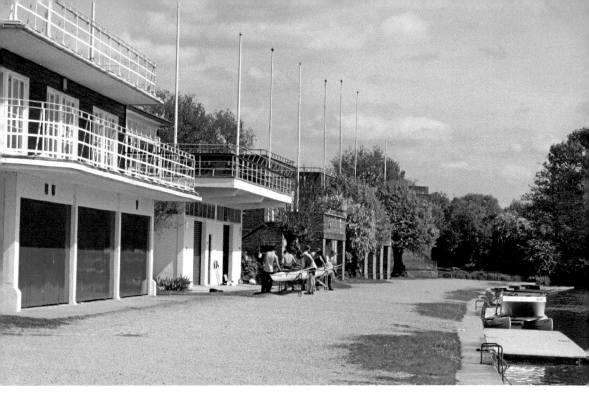

An eight being readied outside a neighbouring boathouse.

commitment. Each college maintains its own rowing club, and the colleges compete twice a year; the Torpids are raced in the spring term, and Eights Week is held at the end of the summer term in May. These races are popularly known as 'the Bumps': on the narrow river, rather than overtaking the boat in front, the objective is literally to 'bump' them from behind. In some colleges it is the tradition to chalk their triumphs prominently on a wall. The ultimate prize is to be Head of the River.

A new university boathouse was built in 2006 downriver at Wallingford. The colleges, however, own or share boathouses within cycling distance of the town centre and to the east (downriver) of Folly Bridge. The boathouse pictured shows that money is still invested in the sport. It is one of several on an island at the end of Christ Church Meadow and displays the arms of Jesus and Keble colleges.

47. Nuffield College, New Road

New Types of Student

The first colleges were graduate-only institutions, but by the eighteenth century the university and its constituent colleges had come to be dominated by undergraduate teaching, though all colleges continued to accept postgraduate students. It was only as the twentieth century progressed and society's demand for graduate qualifications increased, that this pattern began to change. With the advent of graduate colleges, the numbers of undergraduate and graduate students at Oxford are now almost equal. Among current graduate students, 55 per cent are pursuing research degrees while 45 per cent are following taught courses.

Viscount Nuffield, whose huge fortune was based on the motor industry, was a noted philanthropist. In 1937 he founded a college for graduate students, to be named Nuffield College. Given his background, he not surprisingly wanted his college to specialise in engineering but was persuaded that it should be for the social sciences. This was the first Oxford college since the fifteenth century to be founded solely for postgraduate studies. Over the next half century it was followed by several others: St Anthony's (1948), Linacre (1962), St Cross (1965), Green (now Green Templeton, 1979), Wolfson (1981) and Kellogg (1990). It was also the university's first mixed-sex college.

A site was acquired at the end of New Road that included part of the former basin of Oxford Canal. In addition, Lord Nuffield gave £900,000 (equivalent to perhaps £55 million today). The architect Austen Harrison produced a design, but the war intervened. By the time building finally began in 1949, Harrison's plans had been revised and strict post-war building controls were in place. In a period in which modernist architecture was gaining critical support, Nuffield adopted a traditional Cotswold-like style, using Clipsham stone and Colley Weston tiles. The result is homely rather than austere. The college's distinguishing eccentricity is its tower, facing the castle mound across New Street; its nine floors form part of the library.

The traditional Cotswold style of Nuffield College is enhanced by its planting.

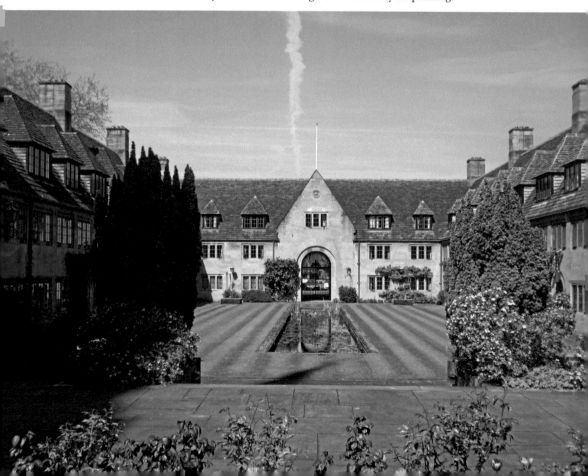

The distinctive tower of Nuffield College overlooks New Road.

Looking into the college through the Worcester Street gate.

48. St Catherine's College

A Growing University

Broadening access to the universities is not a new concern. The Royal Commission of 1850 identified that high fees and college living expenses prevented many capable people from benefitting from a university education. One solution was for the university to admit students without a college affiliation, in this way both reducing their fees and allowing them to control their own living expenses. The Delegacy for Non-Collegiate Students was created in 1868 to admit these students and to give them an institutional focus. In 1931, the Delegacy adopted the name of the St Catherine's Society in order to establish a clear identity for its members: it was becoming more like a college. In 1936, a small building was erected on St Aldates to provide offices and a common room.

The situation changed considerably with the 1944 Education Act, which deliberately aimed to increase social mobility. With tuition now free and maintenance grants available, many of the old financial constraints were relaxed and access to higher education was opened up. In this new world, the University of Oxford was itself seeking to expand, and approval was granted to transform the Society into a full residential college. Land was purchased in 1960, and the Danish architect Arne Jacobsen was selected to create a college from scratch. Work was completed just four years later. Jacobsen was briefed

St Catherine's College and water garden date from the 1960s.

to base his approach on the quadrangle tradition, with rooms served by staircases rather than corridors, but was otherwise given a free hand. The result was the complete opposite of conservative Nuffield College. He delivered a thoroughly contemporary design in the International Style – a modern take on the traditional college – all geometry, concrete and glass, though, surprisingly, partially moated. The water garden (as the 'moat' proves to be) contains a bronze sculpture, *Achaean*, by Dame Barbara Hepworth. The architectural historian Nikolaus Pevsner described the college as 'a perfect piece of architecture', while admitting that its early undergraduates did not share his enthusiasm.

49. Saïd Business School, Park End Street

Maintaining Relevance

The university cannot afford to be left behind as academic research and teaching expand into ever-newer areas. Since the 1950s, many new departments have been established, often boasting generous donors and purpose-built premises. An Oxford Centre for Management Studies was founded as early as 1965.

The Saïd Business School, named for its major benefactor Mr Wafic Saïd, opened in 1996 and mainly offers postgraduate courses. Its new buildings, completed in 2001, were erected

These new premises for the Saïd Business School were completed in 2001.

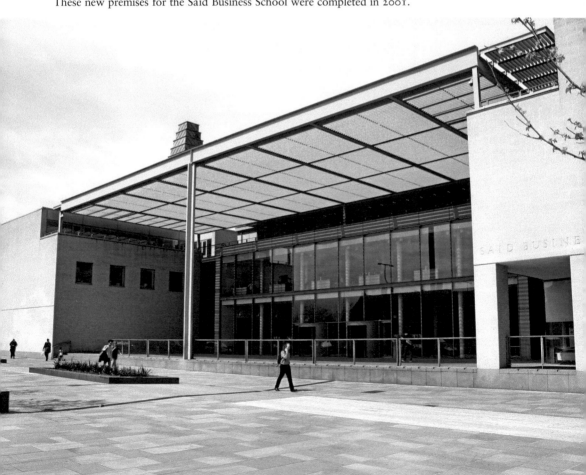

on the site of the former LMS (LNWR) station. Architects Jeremy Dixon and Edward Jones melded state-of-the-art design and modern materials with traditional elements such as columns, cloisters and oak panelling. Its copper pinnacle is a modern take on 'dreaming spires'. In keeping with contemporary concerns, the design is environmentally sustainable. A rooftop theatre in the classical style is ideal for performances on a summer's evening, and commands wide views over the Oxford skyline.

50. Plant Oxford, Cowley

Motor Production and the Growth of Oxford

Although this final building lies on the south-eastern fringe of Oxford, it represents an industry which, over the last 100 years, has done more than any other to shape the modern city. William Morris, later Lord Nuffield, built his first cars in a garage in Longwall Street. In 1913 he took the bold decision to transfer his manufacturing operation to a former Military Training College in Temple Cowley. After the First World War, during which his factory undertook military work, he produced the popular Morris Oxford which made his fortune and created hundreds of jobs. His business model was to make reliable cars at exceptionally low prices supported by bullish economies of scale.

The motor industry was changing when, in 1952, Morris Motors merged with the Austin Motor Co. to form the British Motor Corporation. Several takeovers later, BMW purchased the site from the Rover Group in 1994 and invested significantly in state-of-the-art facilities. Today, the vast modern complex of Plant Oxford lies to the east of the bypass, while Morris' original site over the road has found a new purpose as the Oxford Business Park. Currently, almost 4,000 employees and 1,000 machines produce 900 MINIs each day.

A MINI is displayed on the roof of the state-of-the-art Plant Oxford factory.

Acknowledgements and Further Reading

The author would like to thanks his wife for her constant support. He would also like to thank the editorial team at Amberley. The Dean and Canons of Christ Church kindly provided the photographs of St Frideswide's shrine and the interior of the cathedral.

The author wishes to acknowledge his debt to the numerous books and articles he read while researching this volume. It would be dishonest not to acknowledge Wikipedia as often being the first, though seldom the last, point of information. The following titles will allow the reader to explore further:

Aston, T. H. (general editor), *The History of the University of Oxford*, 8 vols (Clarendon Press: Oxford, 1984–2000).

Crossley, A. & Elrington, C. R. (editors), *A History of the County of Oxford: Volume 4, the City of Oxford* (Inst Historical Research: London, 1979) – available online at http://www.british-history.ac.uk/vch/oxon/vol4 [accessed February-May 2016].

Dodd, A., *Oxford Before the University: The Late Saxon and Norman Archaeology of the Thames Crossing, the Defences and the Town* (Oxford Archaeology, monogr 17, 2003).

Evans, G. R., *The University of Oxford: A New History* (I. B. Tauris: London, 2013).

Salter, H. E. & Lobel, M. D. (editors), *A History of the County of Oxford: Volume 3, the University of Oxford* (Victoria County History: London, 1954) – available online at http://www.british-history.ac.uk/vch/oxon/vol3 [accessed February-May 2016].

Sargent, A., *Secret Oxford* (Amberley Publishing: Stroud, 2016).

Sherwood, J. & Pevsner, N., *The Buildings of England: Oxfordshire* (Penguin: London, 1974).

Tyack, G., *Oxford: An Architectural Guide* (Oxford University Press: Oxford, 1998).

In addition, histories of individual colleges are in print and many colleges publish a guidebook and maintain a website.

About the Author

Andrew Sargent lives near Oxford. He has a degree and doctorate in archaeology and over twenty years' experience working in heritage, and is fascinated by the tangible remains of the past. He has published widely and his previous books include local subjects, *The Story of the Thames* and *Secret Oxford* (both published by Amberley Publishing).